HULL TO BRIDLINGTON RAILWAY

THROUGH TIME

Mike Hitches

AMBERLEY PUBLISHING

Acknowledgements

While it has been enjoyable writing this work, it would have been very difficult to complete without the assistance of several people and I should like to offer my thanks for their help. In particular, Derek Wilson helped with much material. My thanks also go to Roger Carpenter and Mr R. Casserley, who provided historic pictures. Others to thank include my wife, Hilary, and son, Gary, who is trying to make his way in the literary world (and he is better than me). To those I have failed to mention, my apologies and I hope that I have done you justice. Finally, thanks to Northern Rail, whose service has allowed me to run up and down the Hull–Bridlington line collecting material.

First published 2014

Amberley Publishing
The Hill, Stroud, Gloucestershire, GL5 4EP
www.amberley-books.com

Copyright © Mike Hitches, 2014

The right of Mike Hitches to be identified as the Author of this work has been asserted in accordance with the Copyrights, Designs and Patents Act 1988.

ISBN 978 1 4456 1163 1 (print)
ISBN 978 1 4456 1186 0 (ebook)

British Library Cataloguing in Publication Data.
A catalogue record for this book is available from the British Library.

Typesetting by Amberley Publishing.
Printed in Great Britain.

Introduction

The seaport at Hull was initially connected to the railway network with the opening of the Hull & Selby (H&S) Railway in 1840. Making an end-on connection with the Leeds & Selby Railway, it gave the port access to the West Riding of Yorkshire and even as far away as Manchester. It was the Hull & Selby Railway that proposed a line to Bridlington, and this was authorised on 30 June 1845, along with George Hudson's York & North Midland Railway (Y&NMR) line from Seamer, near Scarborough, which would make a head-on connection with the H&S at Bridlington. A plan for a line from Bridlington Quay to the Leeds & Selby Railway had been made earlier, in 1834, but nothing came of it. These new railways would give Hull a direct connection with both Bridlington and Scarborough (via the main York–Scarborough line at Seamer).

The Hull to Bridlington Railway was originally planned as a single-track line, but was completed as double-track by Messrs Jackson & Bean, who also installed the new electric telegraph system. The route runs over relatively flat terrain and several level crossings were provided. Indeed, Beverley has three in close proximity to one another. The 'crossing-keeper' cottages were built by the Y&NMR and many are now private homes.

The Hull–Bridlington line was opened on 6 October 1846, now part of the Y&NMR, with due ceremony as befitting any extension to the Hudson Empire, complete with 'sumptuous luncheon' on the day. While the H&S had a station at Railway Street in Hull, passengers from Bridlington arrived at the city by road coach, the line lying west of Hull. Thus, pressure was applied for provision of a new station in the town and an Act was obtained by the Y&NMR to construct a new station in Paragon Street, along with a hotel.

Architect G. T. Andrews of the Y&NMR designed the new station, and a tender of £51,500 for construction was accepted on 1 March 1847. Hull Paragon station was opened on 8 May 1848, with the adjoining Royal Station Hotel, also designed by G. T. Andrews, opening in 1851. As if to give credence to the 'Royal' in the hotel's name, Queen Victoria,

Prince Albert and five of their children stayed at the hotel while on a visit to Hull on 13/14 October 1854. The original Railway Street station became a goods depot after Paragon Street station was opened.

As the twentieth century dawned, Paragon station was becoming too small for the volume of traffic being handled there – extra passengers had been generated with opening of branches to Withernsea and Hornsea, as well as services to Doncaster and York. In 1902, tenders totalling £75,098 were accepted by the North Eastern Railway, who now owned the station, for various alterations and additions, which involved rebuilding the original platforms, adding new ones and construction of an overall roof. These new station improvements came into use from 12 December 1904. Following nationalisation and increasing road competition, rationalisation of the station took place as branches closed, leading to closure of platforms by 1965.

In the early years of the Hull to Bridlington line, traffic was mainly agricultural, with very few passenger trains. By 1910, there were six through trains between Hull and Scarborough, most stopping at all stations and taking around two and a half hours to cover the 53.75 miles. There was also a 5.30 p.m. non-stop service between Hull and Bridlington, the 30.75 miles taking 40 minutes. A further train left Hull at 4.50 p.m. for Scarborough, calling only at Filey, and arriving at its final destination at 6.05 p.m. A semi-fast train left Hull at 4.55 p.m., called at Cottingham, Beverley, Driffield, Bridlington, Flamborough, Hunmanby and Filey, arriving in Scarborough in 1 hour 38 minutes. On Saturdays, this train stopped at Bempton and Speeton on request. On Sundays, there was a 7 a.m. train from Hull and a 5 p.m. service from Scarborough, calling at all stations and taking 2 hours 25 minutes. As tourism grew in the area, services increased accordingly over the years and were supplemented by excursion and holiday trains during the summer months, fully justifying construction of the line.

Although excursion trains have long gone, the line between Hull and Bridlington is well served by Northern Rail services, who operate half-hourly trains throughout the day. Some trains run through to Scarborough and Sheffield/Doncaster, which give access to shopping centres in Scarborough, Hull, Sheffield and Doncaster and allow the line to have a bright future. The line is also well publicised and supported by the Yorkshire Coast Community Rail Partnership, which should further ensure the future of the whole line from Scarborough to Hull.

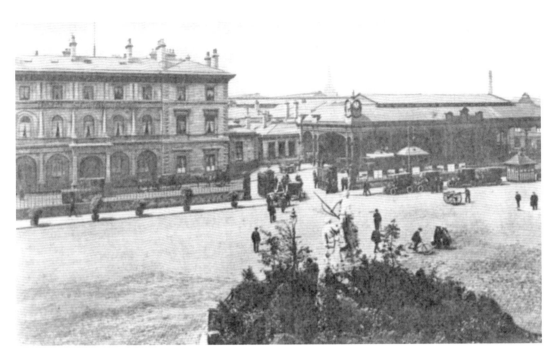

Hull Paragon Station

Hull Paragon station as it appeared before the North Eastern Railway (NER) approved extensions in 1904. Waiting outside the train shed are motorised taxis as well as horse-drawn vehicles in Paragon Square. Below, in May 2014, the extensions are clearly visible and are an attractive addition to the station.

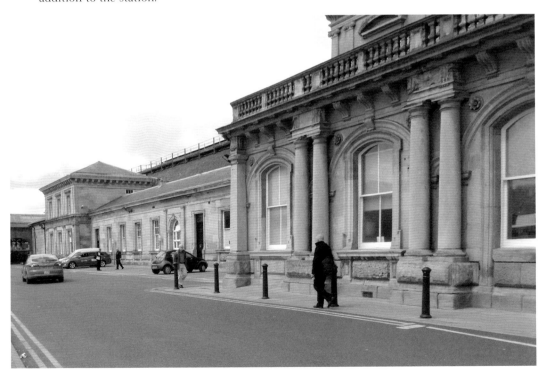

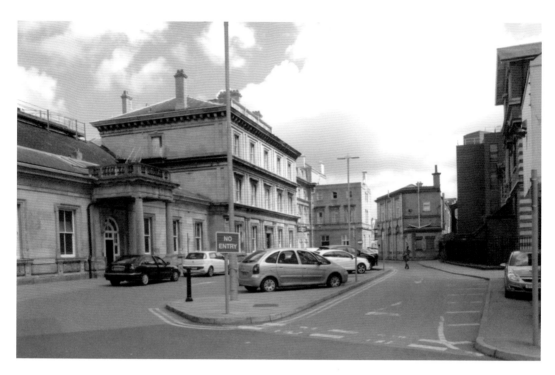

Hull Paragon Station

Another view of the extensions to Paragon station, along with the rear of the Royal Hotel, which was originally opened with the station and became famous when Queen Victoria and her family stayed there. Below is a closer view of the side of the Royal Hotel.

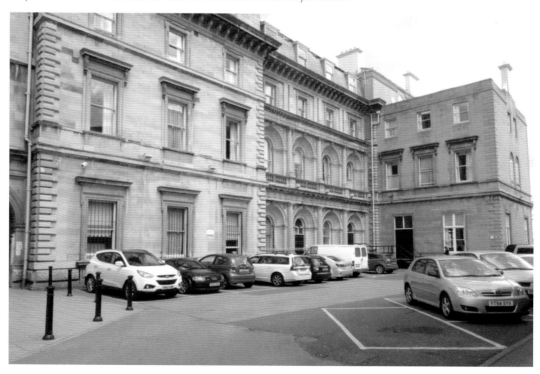

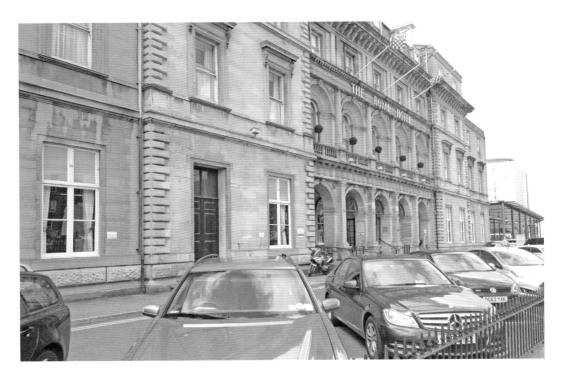

The Royal Hotel
Two views of the front of the Royal Hotel. Three flags are flying near the roof and include one featuring Hull City FC, who were due to play against Arsenal in the FA Cup final at Wembley, their first-ever appearance, on Saturday 17 May 2014, a few days after these views were taken. Sadly, Hull City lost 3-2 after extra time, having taken a two-goal lead in the first ten minutes.

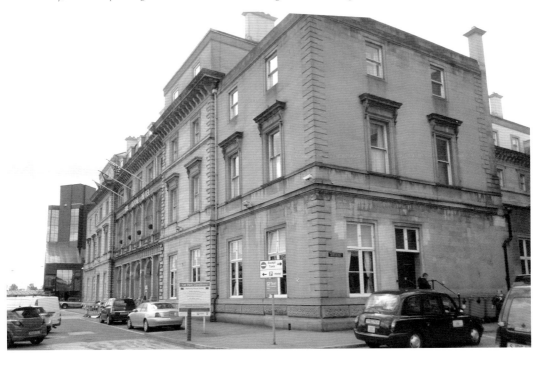

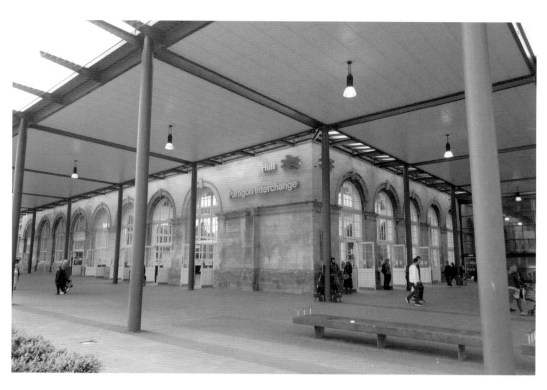

Concourse, Hull Paragon Station

Above is the exterior of the Concourse at Paragon station in May 2014, while below is the view of the shopping complex and Holiday Inn hotel beyond.

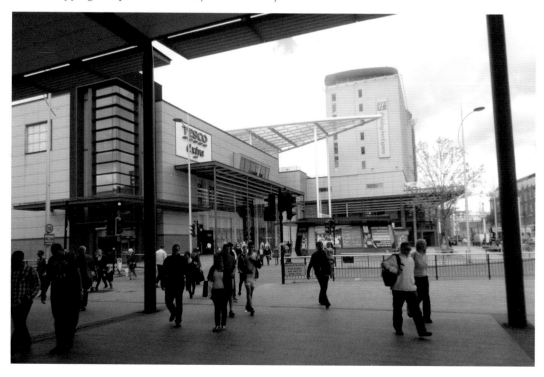

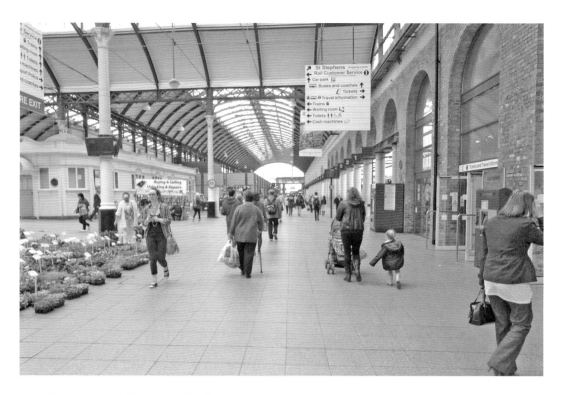

Concourse, Hull Paragon Station

Two views of the concourse at Paragon station in May 2014. The upper view shows the rear of the Royal Hotel and the entrance to the platforms on the left. Below is the concourse leading to the bus station, making the station an exchange between the two.

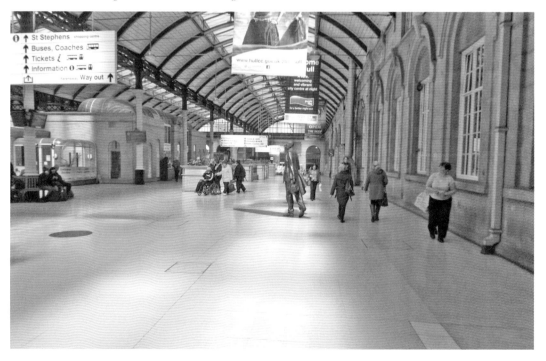

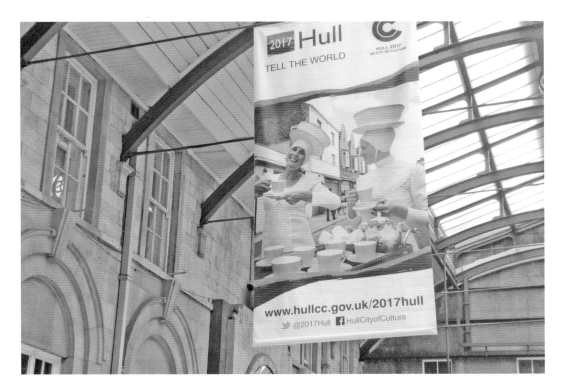

Paragon Station

Hull will become the European City of Culture in 2017, and the banner seen here is advertising this in the upper view. The photograph looks north from the buffer stops at Paragon station with a First Transpennine Express train awaiting departure for Leeds and Manchester (14 May 2014).

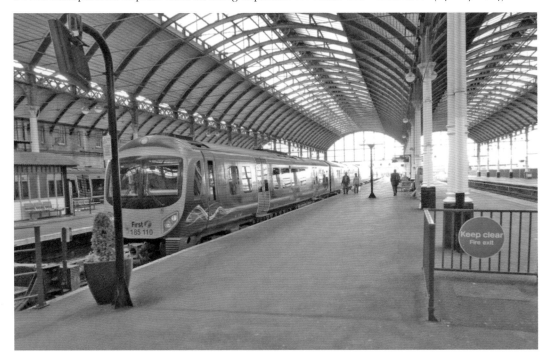

Bus Station
The area around the bus station beyond the station, with several buses belonging to Hull-based East Yorkshire Motor Services. A coach station is also on the same site and, below, a London-bound coach is waiting to collect passengers.

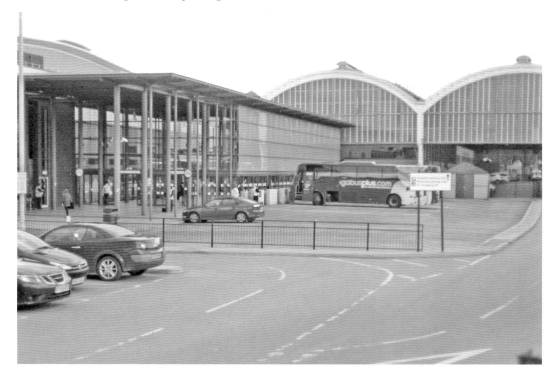

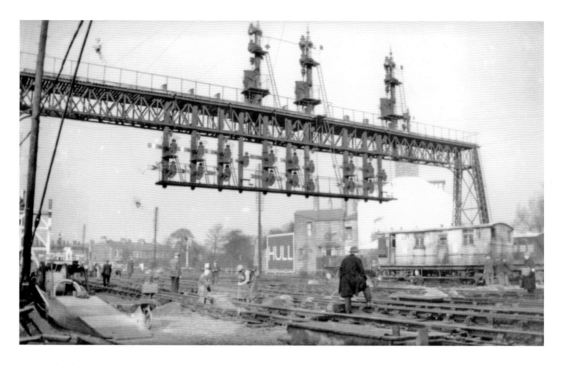

Platform End, Hull Paragon Station

A view of the platform end at Hull Paragon station in the late 1930s, with permanent way work in progress. The signal gantry controlling this section of the station is clearly in view. At this time, the station here was part of the London & North Eastern Railway (LNER). The city and railway would be the scene of enemy air raids in a couple of years' time, the docks here being a prime target. After the Second World War, in April 1947, Paragon station appears in good condition while a shabby looking ex-GNR C12 4-4-2T, LNER No. 7394, is seen departing with a local train.

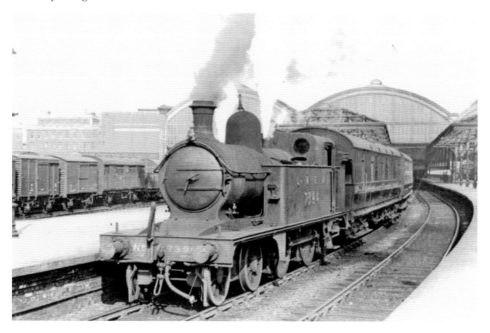

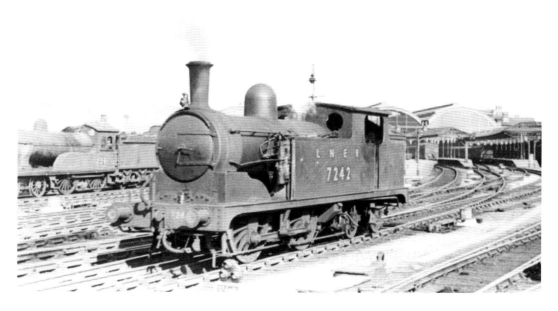

Hull Paragon Station

The view above shows ex-NER G5 0-4-4T No. 7242 simmering at the end of the station as it awaits its turn of duty. Beyond is a D20 4-4-0 No. 2361. Below is the same locomotive preparing to depart with a local train to North Cave, which was situated on the Hull to Barnsley Railway. This had opened in 1885 and was taken over by the NER in 1992, just before the grouping in 1923. The panaromic view of the station acts as a backdrop.

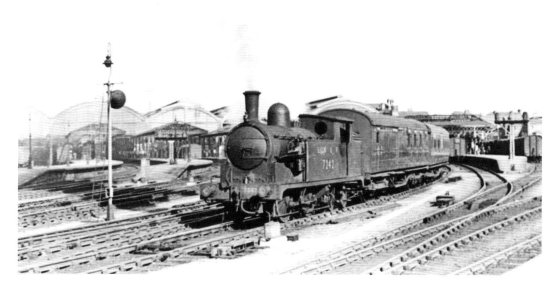

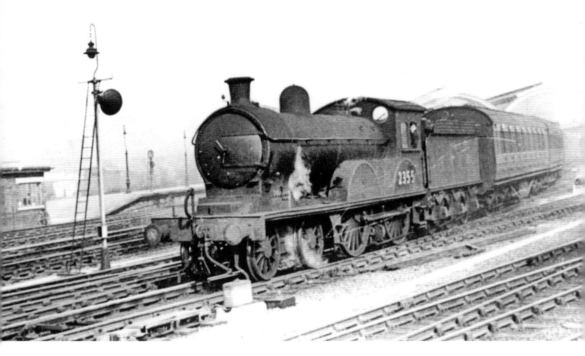

Hull Paragon Station

Still in Hull station in the immediate post-war period, ex-NER D20 4-4-0 No. 2361 is waiting at Paragon station with a fitted freight train, probably from the docks, the locomotive looking rather shabby. Below, the same engine can be seen in the distance as a foreign locomotive, in the shape of LMS 2P 4-4-0 No. 585, waits to depart with the 6.37 p.m. service to Wakefield.

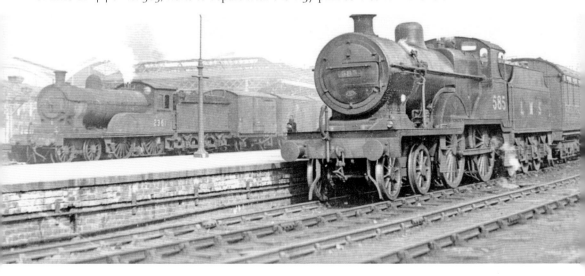

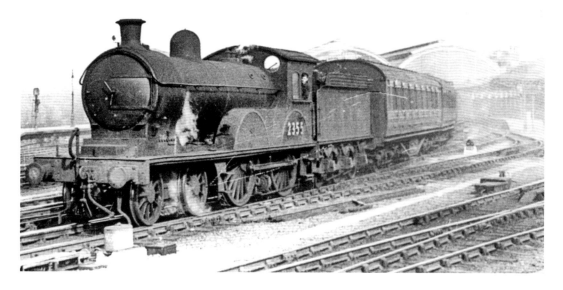

Hull Paragon Station

Above, and another ex-NER D20 (NER Class R) 4-4-0 No. 2355 is waiting to leave the station with a fast train for Scarborough. On the same day in 1947, G5 0-4-4T No. 7321 is about to depart with a local service to North Cave on the old Hull & Barnsley Railway. At this time, there were local services along part of the old Hull & Barnsley Railway (H&B) to South Howden (until 1955), and there were also such trains serving branches to Hornsea and Withernsea until 1964. These lines closed and the system around Paragon station was rationalised. The only main lines now open are those to Doncaster and to Scarborough via Bridlington, Filey and Seamer.

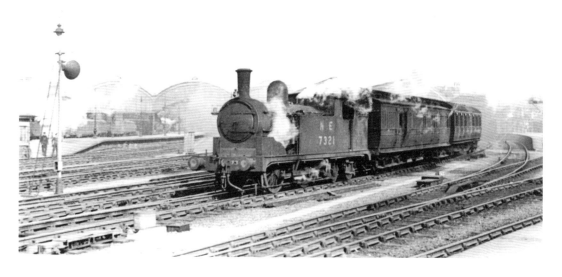

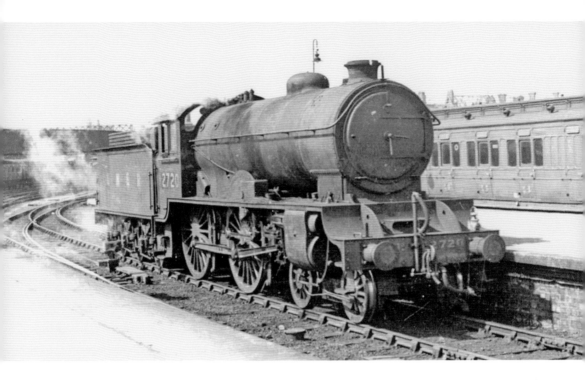

Hull Paragon Station

Standing at the end of Paragon station is LNER Gresley Class D49/1 4-4-0 No. 2720 Cambridgeshire, while below is another member of the class, No. 2703 Hertfordshire, at Hull in April 1947. These locomotives were designed by Sir Nigel Gresley as three-cylinder passenger engines with Walschaert's valve gear. They were named after 'shires', as in these examples.

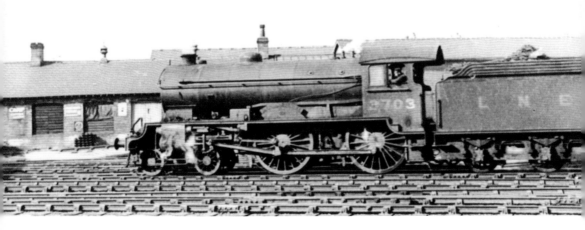

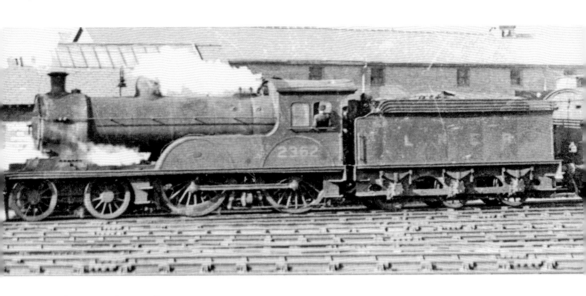

Train to Scarborough

Above, LNER Class D20 4-4-0 No. 2362 departs with a train for Scarborough. These engines were designed by William Worsdell as Class R 4-4-0s and sixty were built between 1899 and 1907, the last of these being scrapped in 1957. Below, ex-NER N8 0-6-2T in wartime livery shunts vans at Hull in 1947.

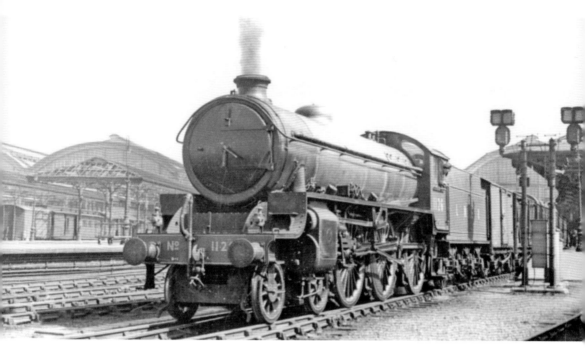

Hull Paragon Station

LNER Thomson B1 4-6-0s at Hull. Above is No. 1126, then virtually new and in the company's express apple-green livery, being run in on freight traffic in April 1947, while another example of the class, BR No. 61406, is seen leaving the station on a wet day in 1964 looking rather neglected. At this time, she only had two years of life left. She was scrapped in 1966 after only sixteen years of active life, having been built in Darlington, under British Railways (BR) auspices, in 1950.

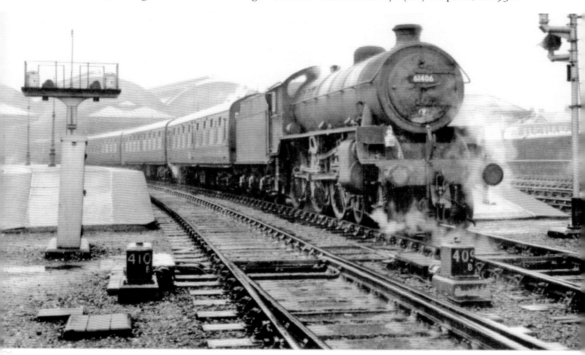

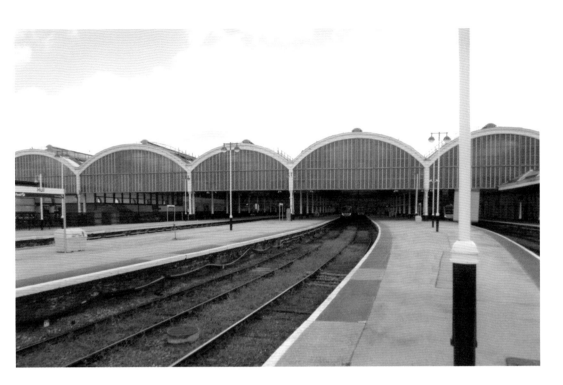

Station Roof

The station roof at Paragon station in May 2014, which was part of the new station that was constructed in 1904. Below is the original station roof, which is visible in the view of the station from Paragon Square, and remains in use today.

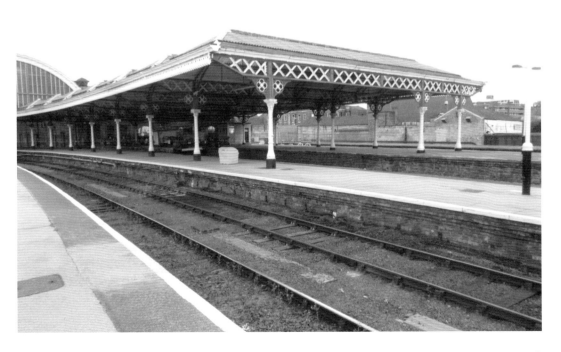

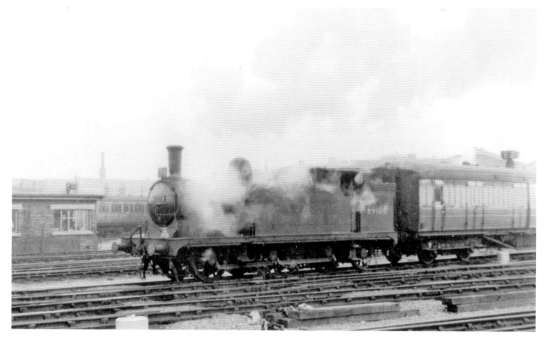

Hull Paragon Station

Above is ex-NER/LNER Class N10 0-6-2T with BR No. 69108 leaving Hull with a passenger train on 31 August 1956. Below, and some fifty-eight years later, on 14 May 2014, a First Hull Trains service is leaving the platform at Paragon station, having brought in a train from Kings Cross, leaving the East Coast Main Line (ECML) at Doncaster.

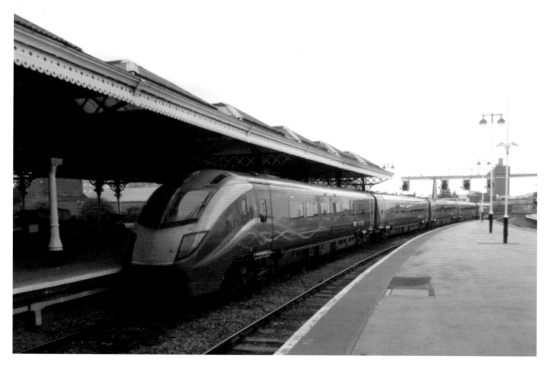

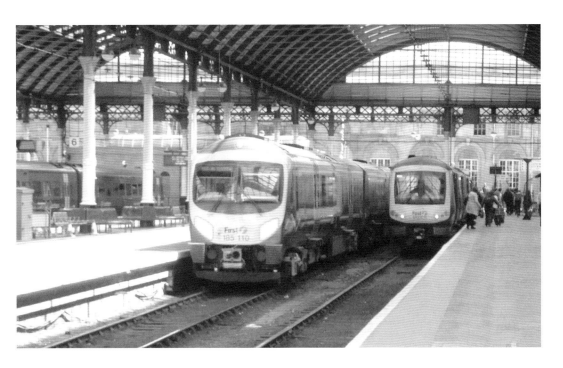

Hull Paragon Station

Looking towards the buffer stops at Paragon station in May 2014, First Transpennine Express trains are resting after bringing in passengers from Liverpool and Manchester. Below, another Transpennine Express, No. 17303, is about to depart with a service to Liverpool.

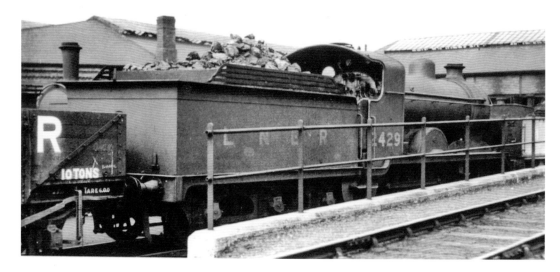

Dairycoates

Hull was (and to some degree, still is) a major port with imports and exports keeping the railway busy. There was also a lively fishing industry, which brought traffic to the railway in the Hull area. To cope with this, the city had several locomotive sheds, the largest of which was at Dairycoates and provided freight engines for such traffic. Many of the following views show the various types of locomotives that inhabited the shed. Above is ex-Hull and Barnsley Railway 0-6-0 No. 2429 at the dead end of the shed on 21 June 1931. Below is ex-NER Raven Class W, now LNER Class Q6 0-8-0 No. 771, a heavy freight engine seen here on the same day.

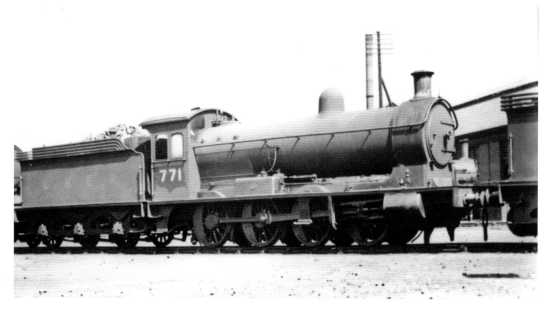

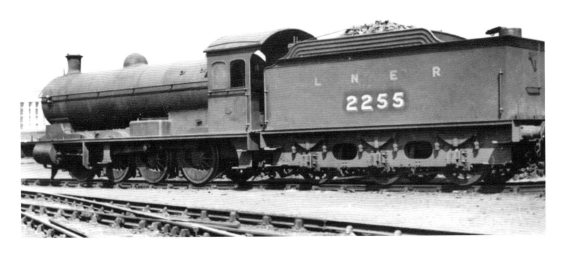

Dairycoates

Another Raven Q6, No. 2255, at Dairycoates on 21 June 1931. Below, on 17 April 1947, is ex-NER (now LNER) Class A7 4-6-2T No. 9788, running from Dairycoates shed to take up duties on 17 April 1947.

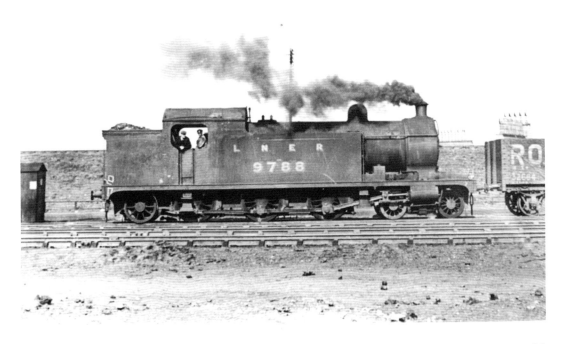

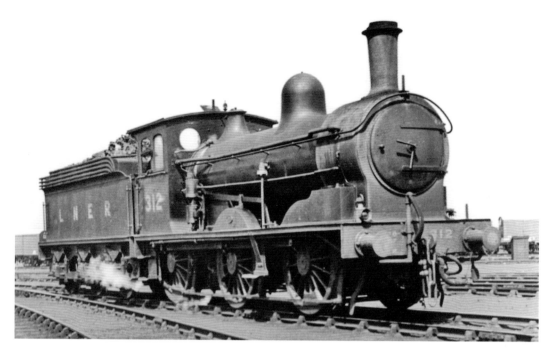

Dairycoates

Above is ex-NER, now LNER Class J21 0-6-0 No. 312 at Dairycoates on 4 June 1938, while below is ex-GCR Robinson Class B8 4-6-0 No. 1349, in company with NER Class J25 0-6-0 No. 5712.

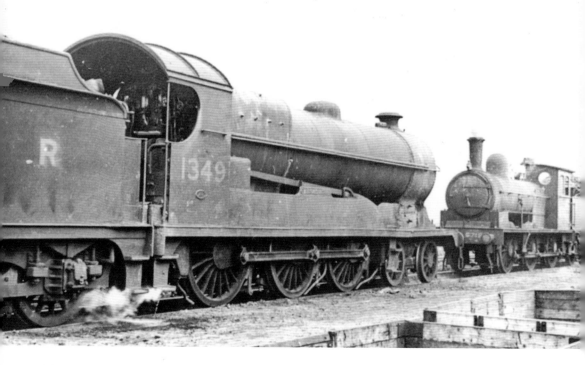

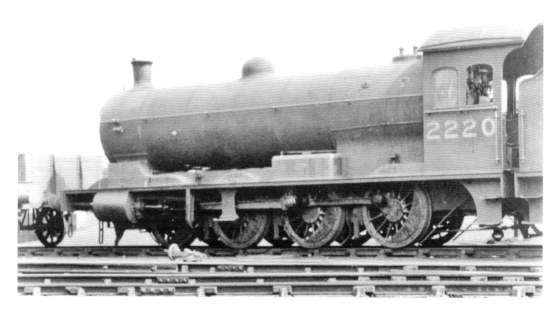

Dairycoates
Another LNER Q6 0-8-0 No. 2220 is at Dairycoates on 21 June 1931, while below is Class J25 0-6-0 No. 5712 at the same location in 1947.

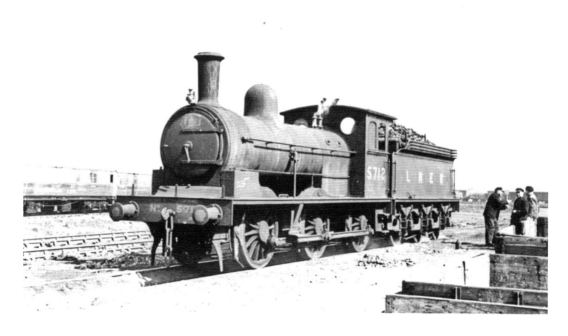

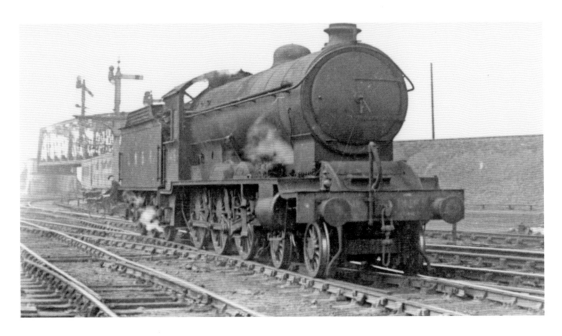

Dairycoates

Above, waiting on Dairycoates shed road on 17 April 1947, is ex-NER three-cylinder Class B16 4-6-0 No. 1416. Below, ex-Austerity 2-8-0 LNER Class O7 No. 8158 is being serviced at Dairycoates on 17 July 1947.

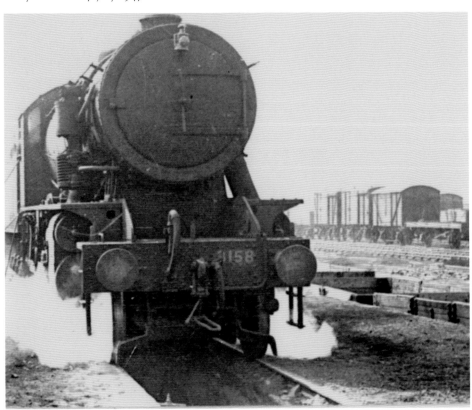

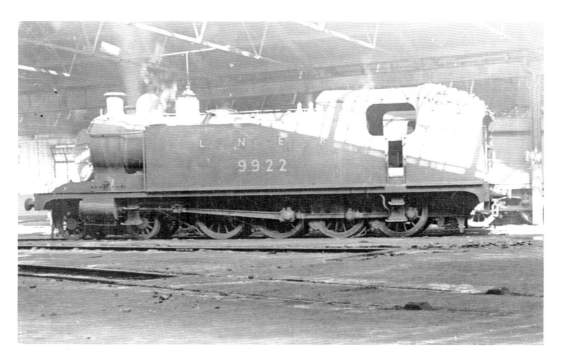

Dairycoates
LNER heavy freight 4-8-0T No. 9922 is seen inside Dairycoates shed on 17 April 1947. Below, several engines surround the turntable on the same day, with Q6 0-8-0 No. 3444 in the foreground.

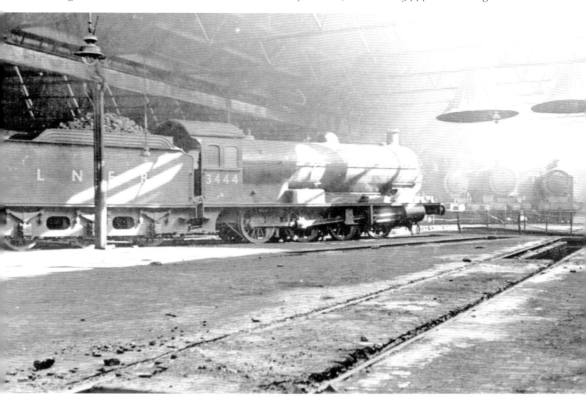

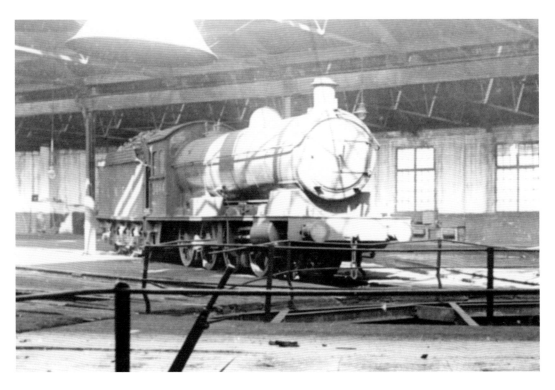

Dairycoates
Another view of Q6 0-8-0 No. 3444 at the turntable is in the upper view, while below, LNER Class C6 Atlantic is on the turntable road on the same day.

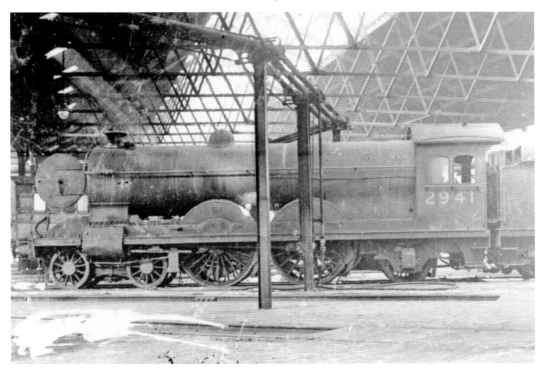

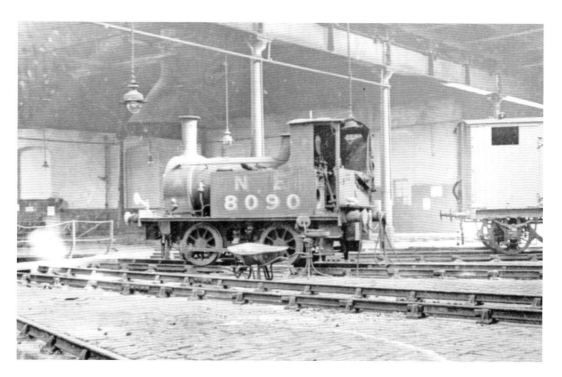

Dairycoates

A year before scrapping in 1948, Class Y8 0-4-0 shunting tank No. 8090 rests inside Dairycoates shed in the upper view. Below, outside the shed, is ex-GCR B8 4-6-0 No. 1349 awaiting her duties.

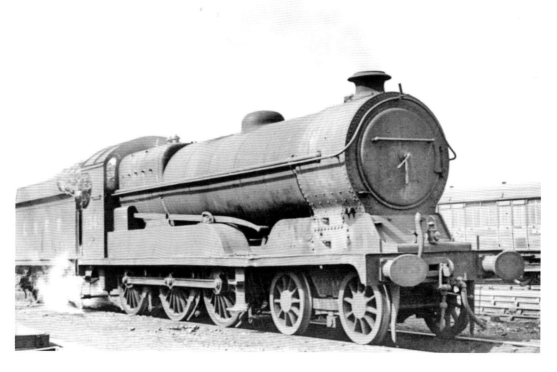

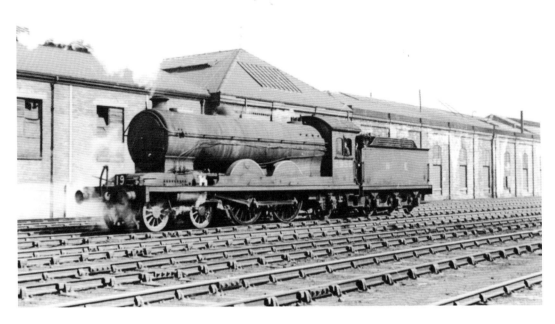

Dairycoates

Two more engines at Dairycoates on 17 April 1947. Above is C7 Atlantic No. 2958, still in wartime livery, while below is N8 0-6-2T No. 9397.

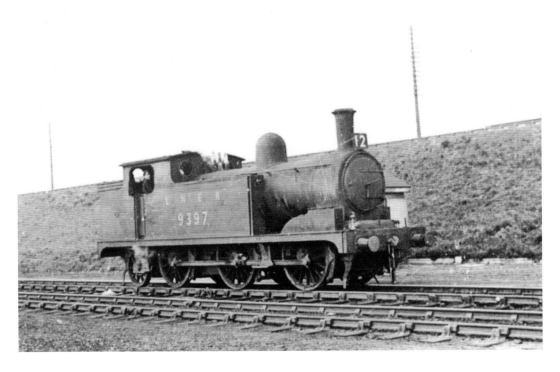

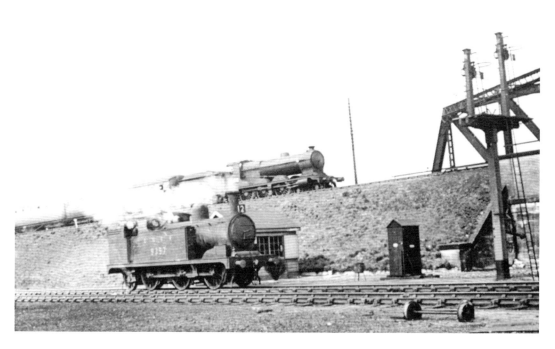

Dairycoates

Above is another view of No. 9397 outside Dairycoates shed as ex-Robinson Great Central Railway Class B5 4-6-0 passes, with an express on the embankment above. Below, on the same day (17 April 1947), LNER Class A8 4-6-2T No. 9855 passes Dairycoates with a local train.

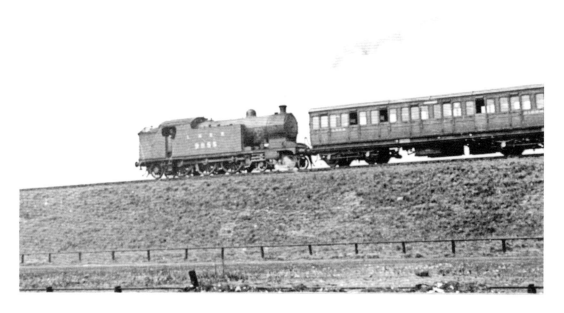

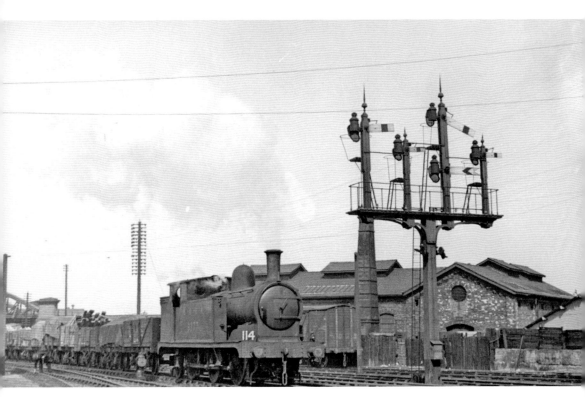

Dairycoates
Above, Class N8 0-6-2T is coming up from the docks and past Dairycoates with a goods train. Another freight train below is also passing Dairycoates, headed by J25 0-6-0 No. 5705, both on 17 April 1947.

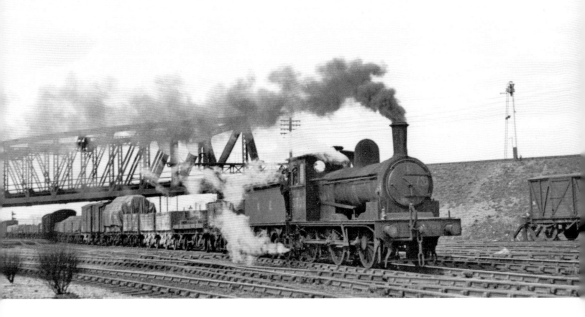

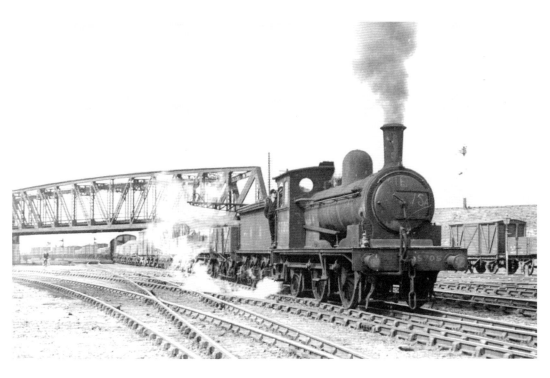

Dairycoates

Above is another view of No. 5705 on another freight from the docks on 17 April 1947. Below, and seven years later, ex-LNER Class A8 4-6-2T with BR No. 69881 is hauling a local train from Hull and heading towards Cottingham on the line to Bridlington and Scarborough.

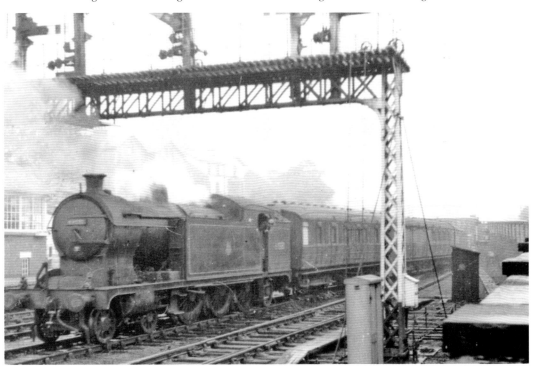

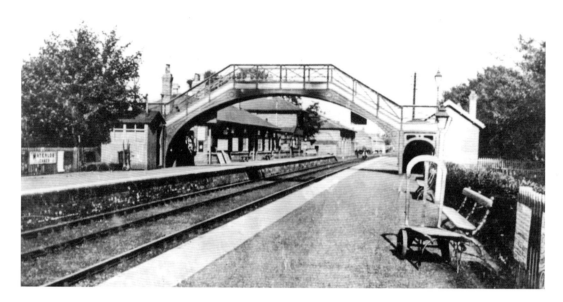

Cottingham Station

The first station on the Hull–Bridlington Railway is at Cottingham. The upper view shows the station in NER days, while the one below was taken on 31 August 1958 when it was under BR control. As can be seen, there have not been many changes between the two views, although a shed for bicycles has now been provided. Before Beeching and the rationalisation of the railways in the Hull area, trains from Doncaster (via Goole) to Bridlington during the summer months ran via Hessle Road Junction to Cottingham South Junction, thereby avoiding a reversal at Hull Paragon. This line closed in 1965 and was replaced by Anlaby Curve, which was later officially closed.

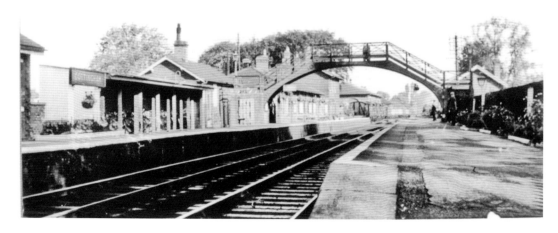

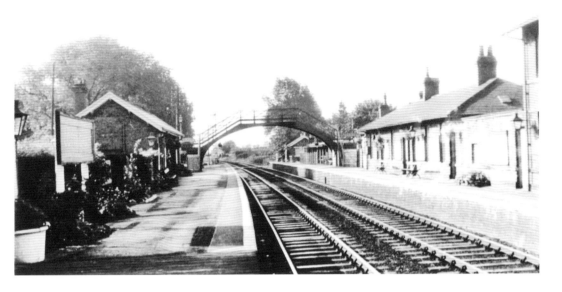

Cottingham Station

Cottingham station looking south as it appeared on 31 August 1956, showing the well-kept station buildings. The lower view shows the station in May 2014, and the Hull-bound platform building still looks well maintained. However, a closer inspection shows that the windows are boarded up as it is now an unstaffed halt. To the right of the picture is a Northern Rail train, which will terminate in Hull.

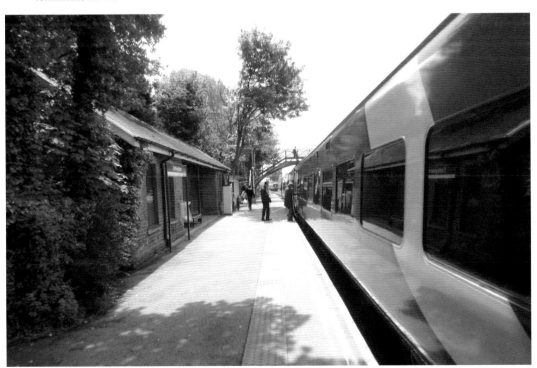

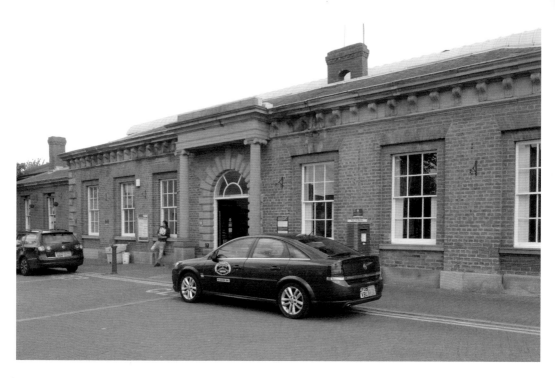

Beverley Station

The above view shows the exterior of Beverley station in May 2014. It shows the main building and entrance into the station area. The view below shows one of the lines south of Beverley station that looks in the direction of Hull.

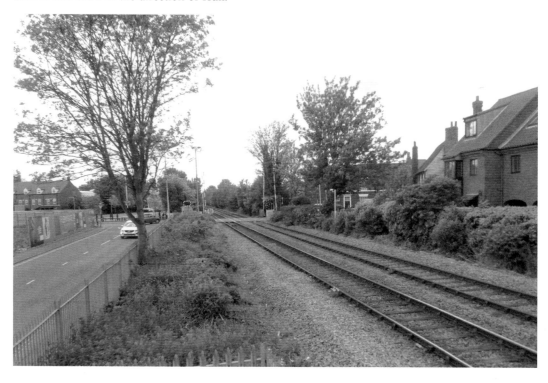

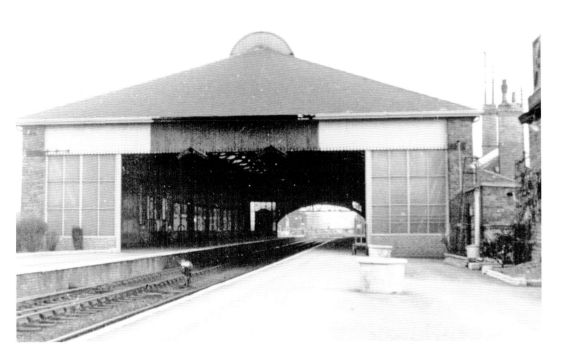

Beverley Station

Two views of Beverley station. The above picture was taken in April 1954, while the lower view shows the station as it appears sixty years later, in May 2014. Both views look similar, although the 2014 view shows weeds growing through the platform tarmac, something which would not have been allowed back in the steam days.

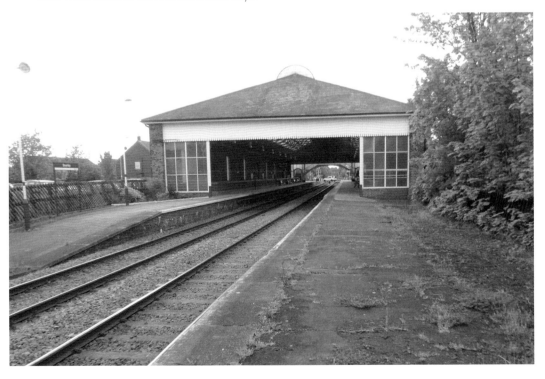

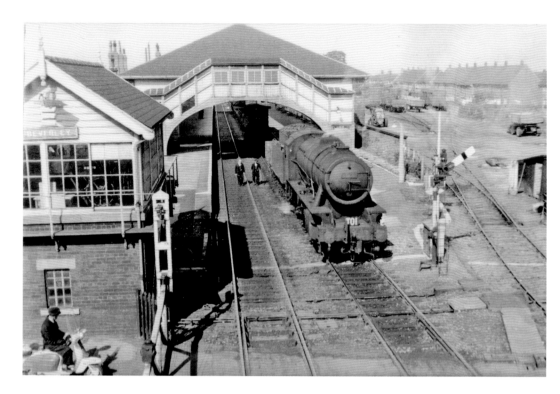

Beverley Station

Above is a view of Beverley station and footbridge looking towards Bridlington in August 1966, with ex-WD 2-8-0 No. 90680 on shunting duties. The siding, looking a little overgrown, is on the right – a sign of the times, perhaps! Below, and under the same footbridge on 14 May 2014, is a Northern Rail train for Hull. These services run every half-hour from Bridlington.

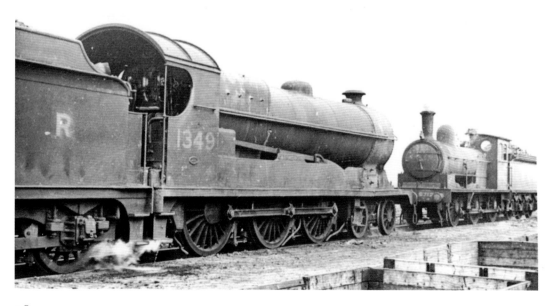

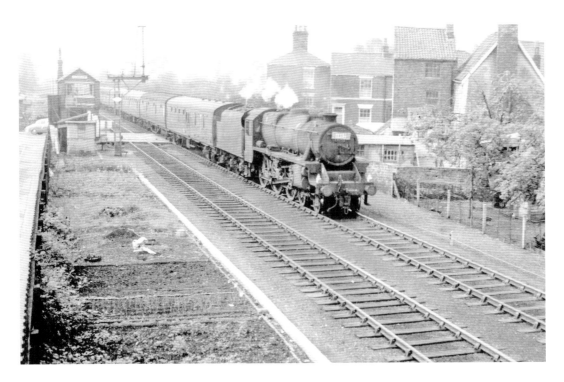

Beverley Station

Beverley, near Flewingate level crossing, on 18 June 1966, with a Bradford to Bridlington Saturdays, only excursion headed by ex-LMS Black Five 4-6-0 No. 44732. The train would have used the avoiding line so that it would not have to reverse at Hull. The view below shows the same level crossing, now with automatic barriers, in May 2014. The signal box is still in situ and appears to be well maintained.

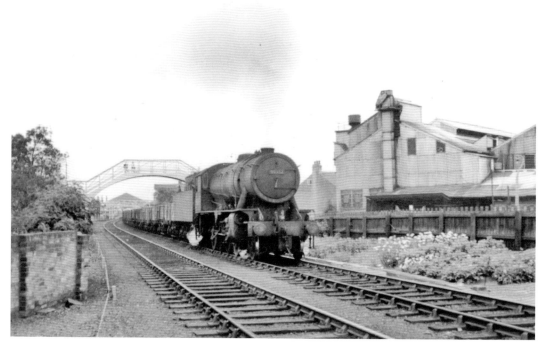

Beverley Station

In 1966, another ex-WD 2-8-0, No. 90352, passes Beverley station with a mineral train. Below is a view of the famous Beverley Minster from the footbridge, just south of the railway station.

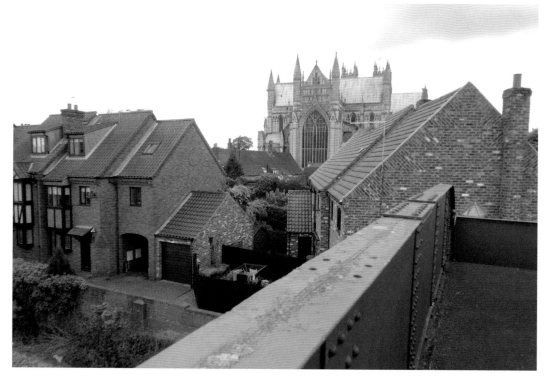

Beverley Station
Above, and from the same footbridge, looking in the direction of Bridlington, Beverley station footbridge can be seen in the distance. Below, Beverley Minster is visible from the railway just south of Beverley station. Both views were taken on 14 May 2014.

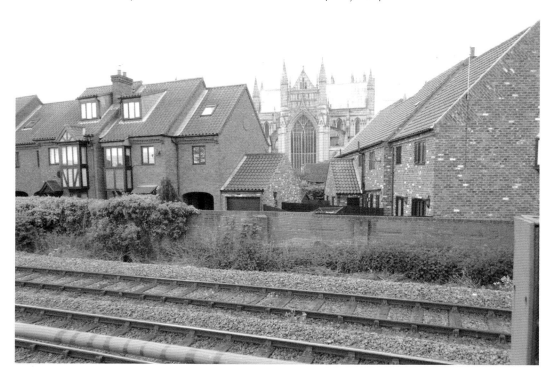

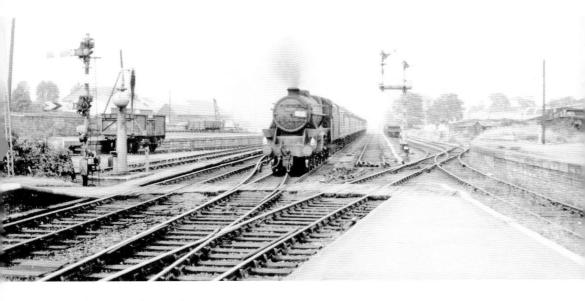

Approaching Beverley Station

In 1966, an excursion is approaching Beverley station from the north. At one time, Beverley was a junction for a branch to Market Weighton, via Cherry Burton, which was closed in 1965. Another branch from Beverley to North Frodingham was proposed by the NER in the early twentieth century, but it never materialised due to a dispute with a canal company who operated in the North Frodingham area. Below, in May 2014, Flewingate crossing can be seen from the road, looking north, showing the old crossing keeper's cottage, signal box and station footbridge.

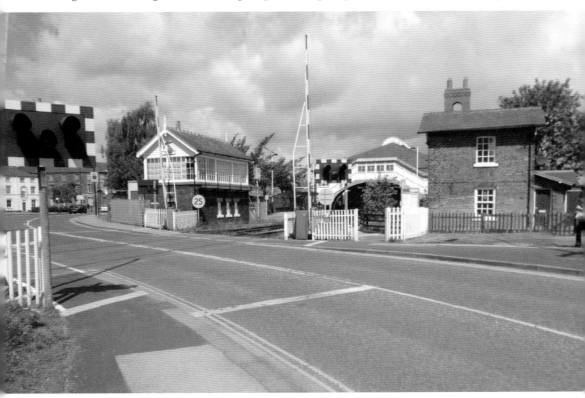

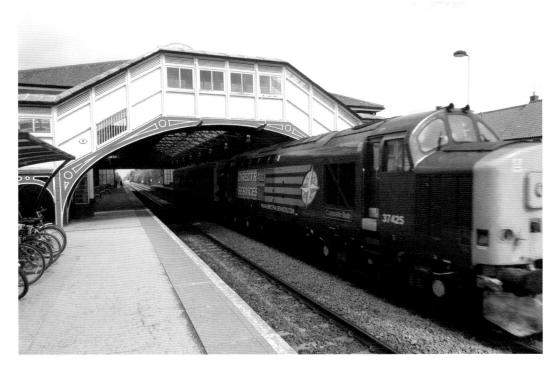

Beverley Station

In May 2014, a Class 37 Co-Co diesel-electric locomotive is seen passing under the passenger footbridge at Beverley with an Inspection Saloon as it heads towards Hull. On the same day, a Bridlington-bound train is arriving under the roof at Beverley station.

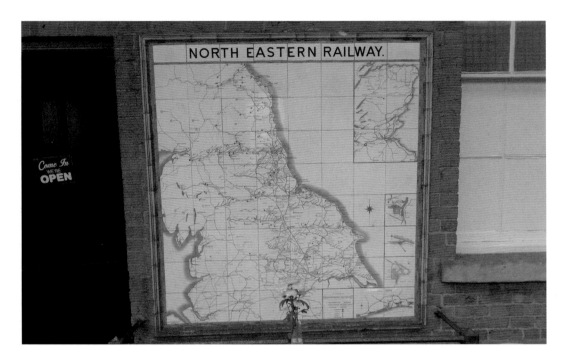

Beverley Station

On the wall, just behind a table serving the station café on the Bridlington-bound platform, is a tile map made for the NER in the early twentieth century. Another similar map is situated at Scarborough station. The lower view shows the North-East Coast network of the NER taken from the same map.

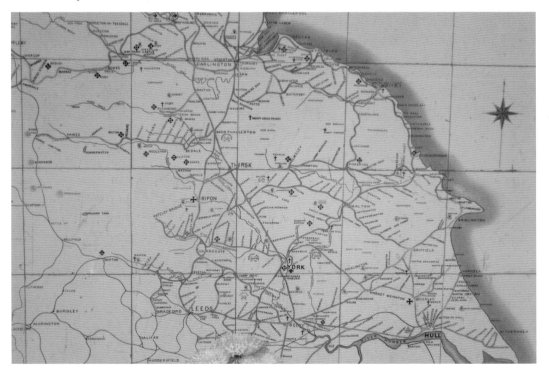

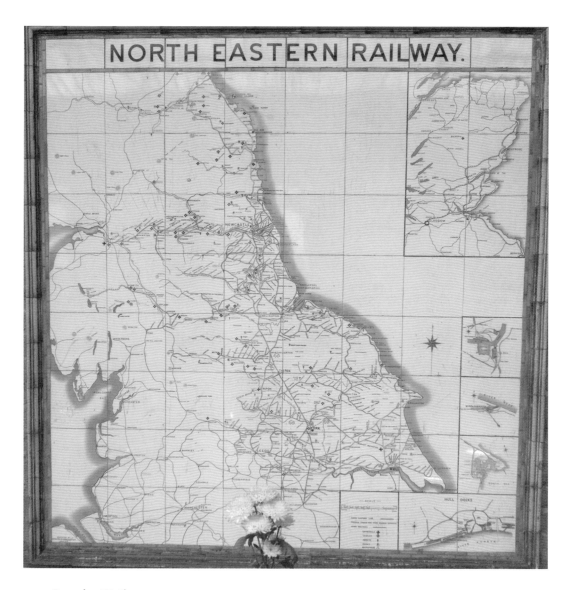

NORTH EASTERN RAILWAY.

Beverley Station

A closer view of the complete NER tile map. In 1900, the NER commissioned large scale tile maps to be displayed at stations, showing the whole of the NER network from Berwick and Carlisle in the north to southern extremities, in places like Withernsea and Swinton. Around twenty-five maps were produced, the last around 1910, and they measured 5 feet 8 inches by 5 feet 4 inches. Along with the ones at Beverley and Scarborough, another ten still exist at their original stations: Hartlepool, Middlesbrough, Morpeth, Saltburn, Tynemouth, York and Whitby. The final map is now on display at the National Railway Museum at York, having been removed from the Great Northern Railway station at Kings Cross.

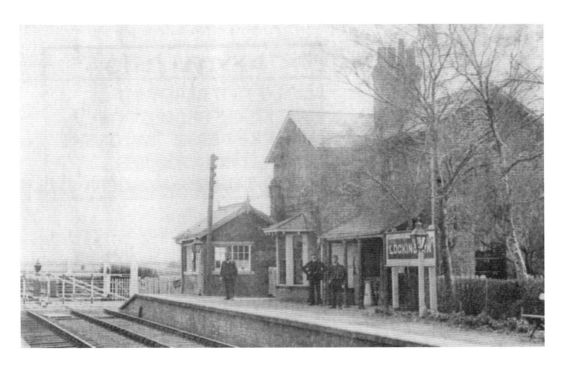

Lockington Station

After leaving Beverley, the railway passes through the little wayside station at Arram, which was close to the RAF base at Leconfield and was used by service staff. At one time, plans were made by the Y&NMR to bring a branch from Hornsea to join the Hull to Bridlington line, but the collapse of the 'Railway Mania' meant that this plan was abandoned. From Arram, the line then passed Lockington (now closed), two views of which can be seen here in NER days. From Lockington, the line runs through another wayside station at Hutton Cranswick before entering Driffield.

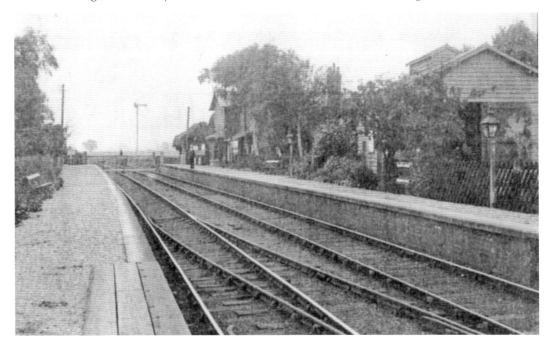

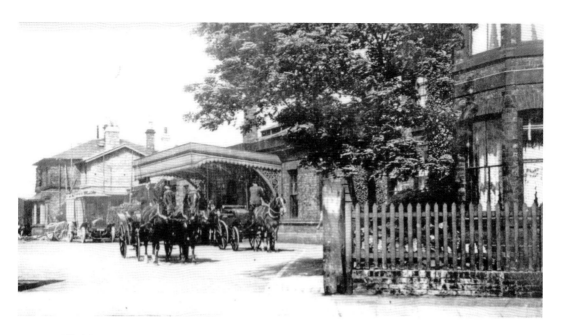

Driffield Station

Above is the exterior and main building at Driffield station early in the twentieth century, showing horse and carriages, along with an early motor vehicle. Below, a little over a century later, on 14 May 2014, the exterior of the main building looks different; it now has a modern canopy above the main entrance door, a café to the left and modern motor cars in the foreground.

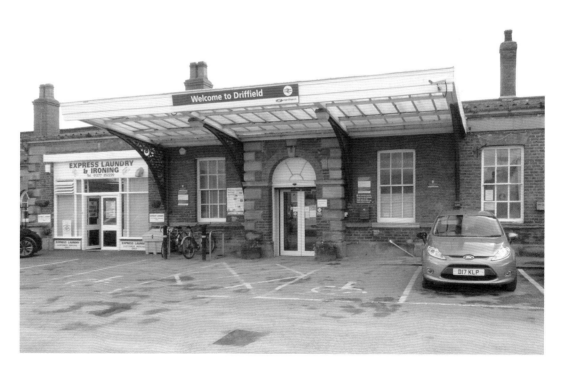

Driffield Station

The upper view shows the exterior of the Hull-bound platform of Driffield station in May 2014, a somewhat simpler structure. Below is the station itself, with its roof over the platforms designed by Y&NMR architect George Andrews. In view is a Bridlington-bound NER locomotive, having just arrived. Driffield was the terminus of a little branch from Malton, via Sledmere & Fimber (where Sledmere House with its Royal connections was situated), which opened in 1853 and closed to passengers in 1958. However, it remained as useful bypass route for excursion trains running to Bridlington and Butlins'holiday camp at Filey. The second line came from Selby and Market Weighton, opening in 1890. The latter line closed in 1965, leaving only the main line between Hull, Bridlington and Scarborough.

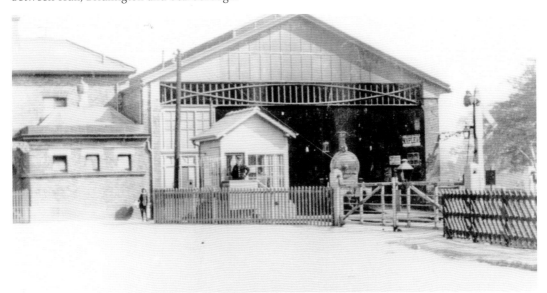

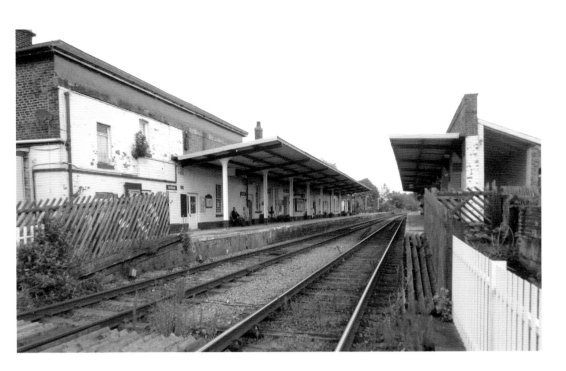

Driffield Station

Driffield station looking towards Hull in May 2014. The overall roof has long gone, replaced by simple canopies over the platforms. All that remains of the roof are the arches on the Hull-bound platform, seen in the lower view.

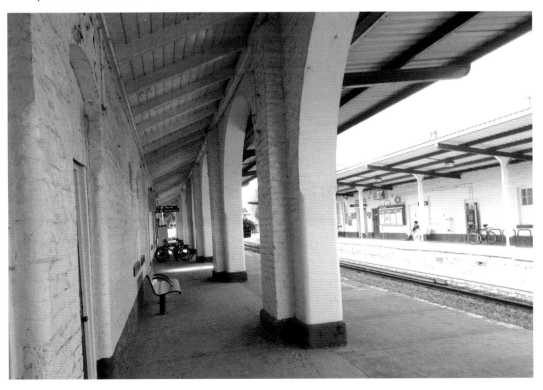

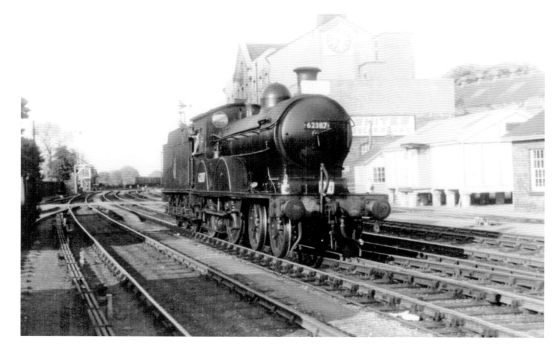

Driffield Station

Standing outside Driffield station, having brought in an excursion train from Malton in June 1957, is ex-LNER Class D20 4-4-0 No. 62387. The locomotive is standing just beyond White's sugar factory, itself a distant memory. Compare the 1957 view to that of 2014 below, where a Northern Rail train has just arrived on its way to Bridlington.

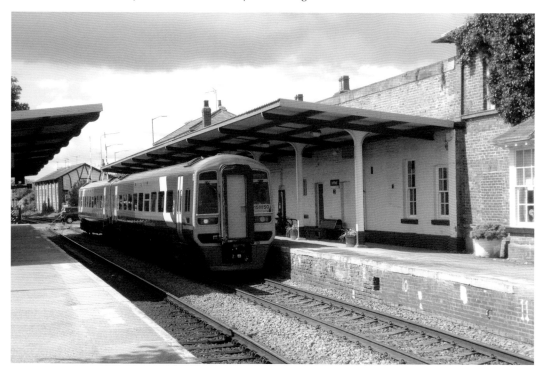

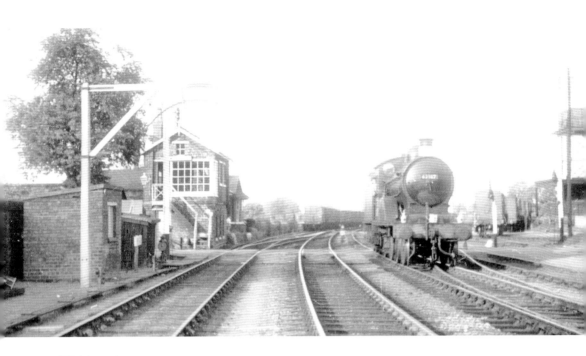

Driffield Station

Above is another view of D20 No. 62387 as it reverses back into Driffield station in 1957, showing the signal box and complex of sidings at Driffield. With plenty of wagons in view, it gives an idea how important this market town was to the railway. A simpler view in 2014 shows another Northern Rail train, this time departing for Hull and Sheffield.

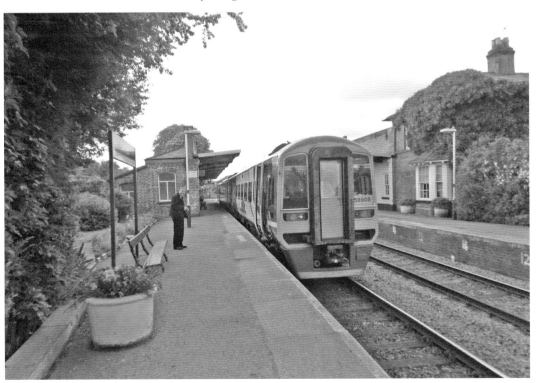

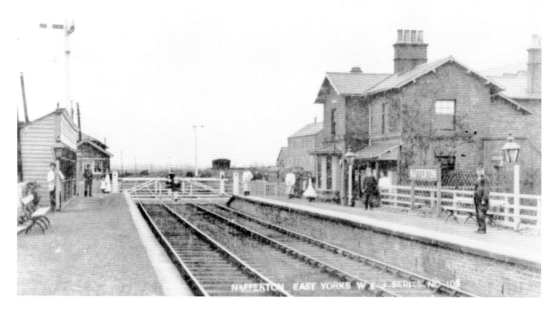

Nafferton Station

Two views of Nafferton station, the next after Driffield, both looking in the direction of Hull. Above is the main building (on the right), a simple wooden waiting shelter, signal box and level crossing in NER days, along with staff and passengers. By 2014, the scene is very different, with just a platform in view on the southbound platform.

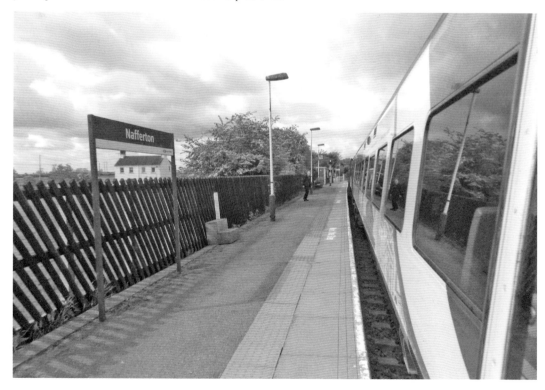

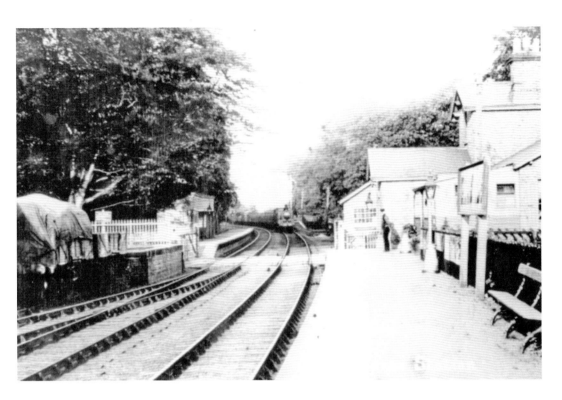

Lowthorpe Station

From Nafferton, the next station on the line was Lowthorpe, seen here in NER days with a train approaching. On the right is the main station building, which, like the closed stations at Burton Agnes and Carnaby, has become private housing. Below is Carnaby station itself, looking towards Hull, in NER days. Both of these stations closed under Beeching as late as 1969, after petitions to keep the line open were accepted.

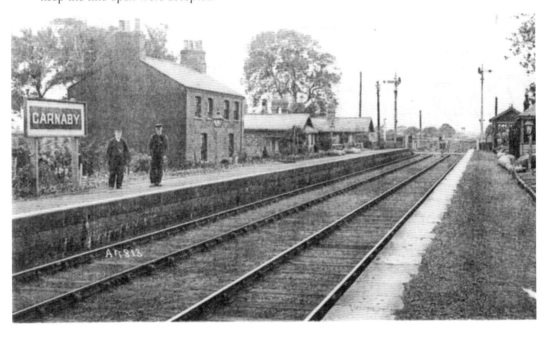

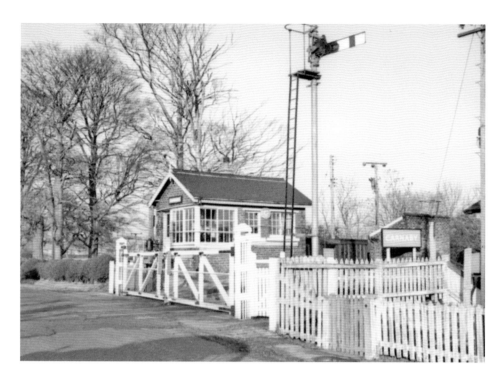

Carnaby Station

The signal box and level crossing at Carnaby in December 1964 contrasts with the automatically controlled level crossing barriers and the abandoned Carnaby station, still with platform and main building, in May 2014.

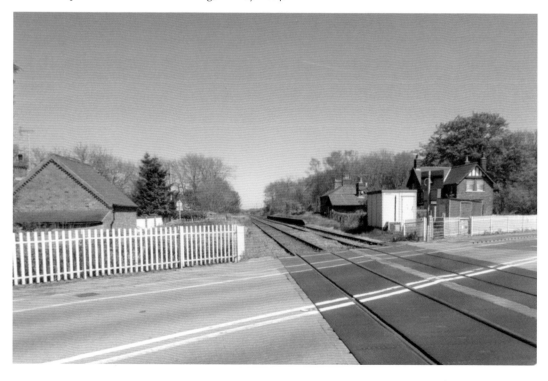

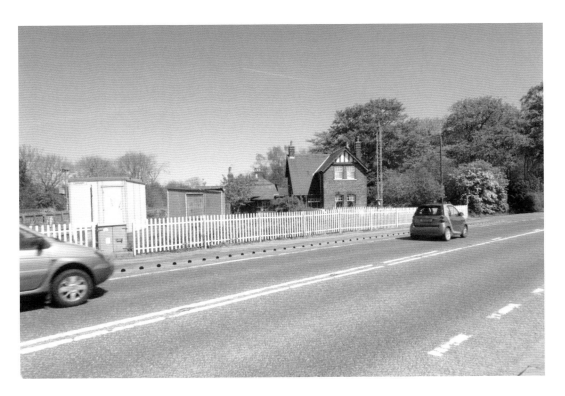

Carnaby Station

Above is the 2014 view of the crossing keeper's cottage (now a private residence) at Carnaby, while below a BR Standard locomotive is passing Carnaby with an excursion in 1964.

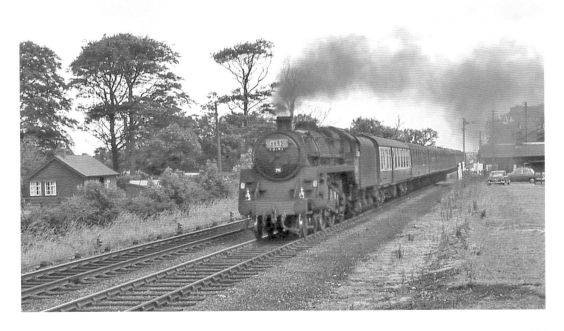

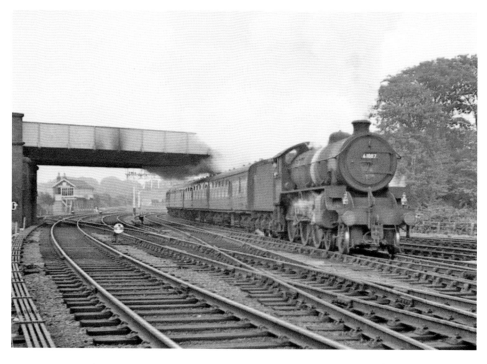

Carnaby Station
An ex-LNER Class B1 4-6-0 No. 61087 is approaching Bridlington station on 4 September 1964, while below another B1 is on a return excursion to Doncaster.

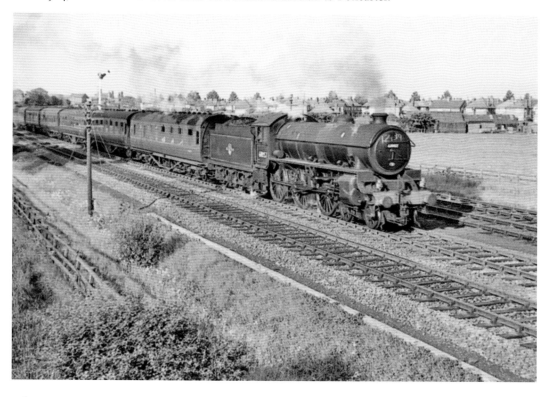

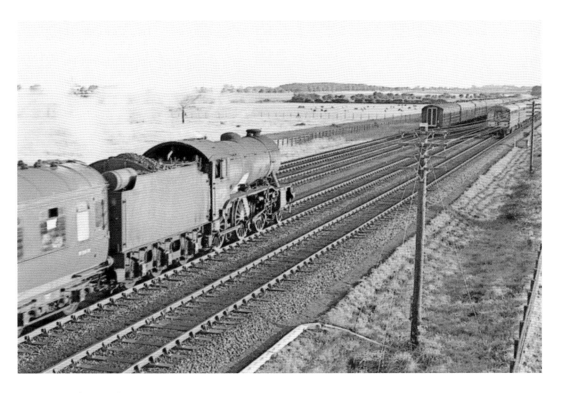

Carnaby Station

Above, K3 2-6-0 No. 61957 is on an excursion at Bridlington in August 1964, while another member of the class is on a southbound train.

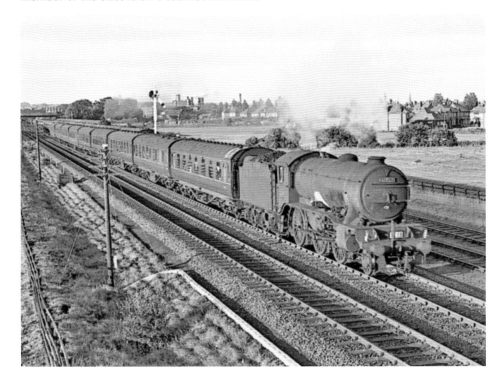

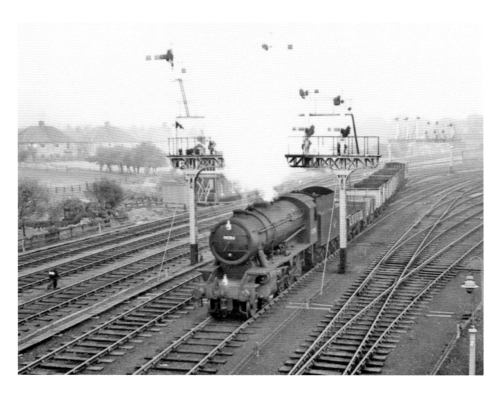

Bridlington Station
An unidentified ex-WD 2-8-0 is Hull-bound with a morning freight in 1964, while another example of the same class is shunting at Bridlington.

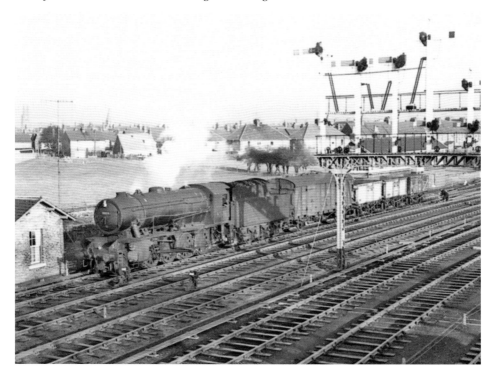

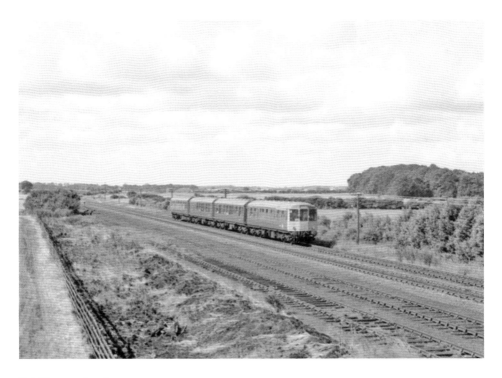

Bridlington Station

Steam traction has been replaced by modern traction by 1967, as these two views of Diesel Multiple Units at Bridlington show. The upper scene is of a train of three sets on a Bridlington to Hull service while, below, a four-car Diesel Multiple Unit (DMU) set is approaching Bridlington from the south.

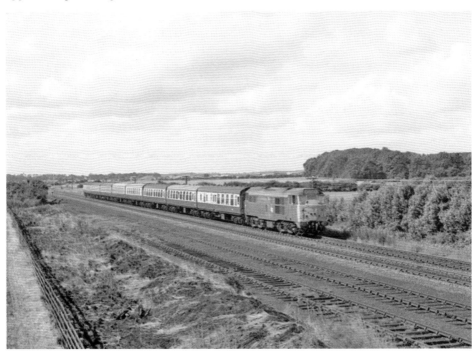

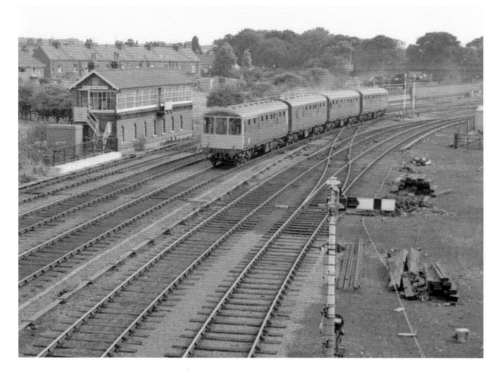

Bridlington Station

Above, another four-car DMU set is leaving Bridlington for Hull in the mid-1960s. Below, modern traction, in the shape of BR Class 20, is heading a short freight train out of Bridlington.

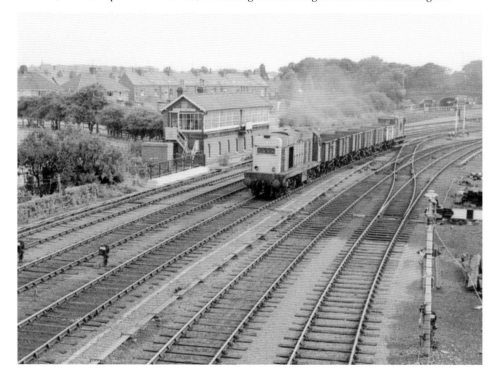

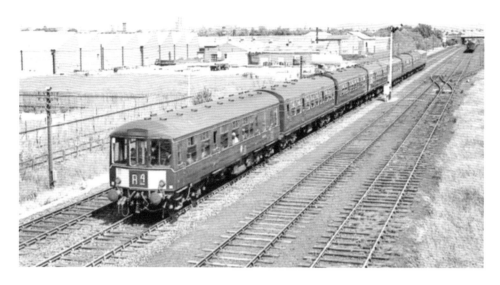

Bridlington Station

By the early 1970s, all steam traction had disappeared from the railway network and had been replaced by diesel traction in the Bridlington area. Here, in the above view, is a Peak diesel-electric locomotive approaching Bridlington in the early 1970s. Below, a BR Class 47 Co-Co diesel-electric is seen approaching Bridlington in the same period.

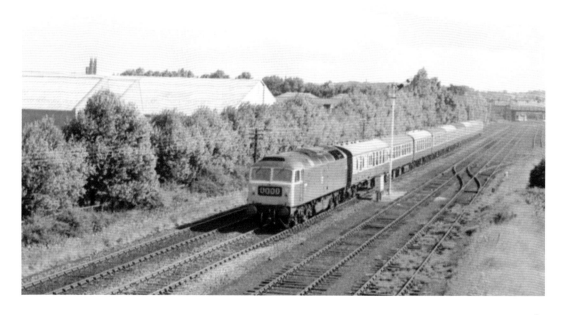

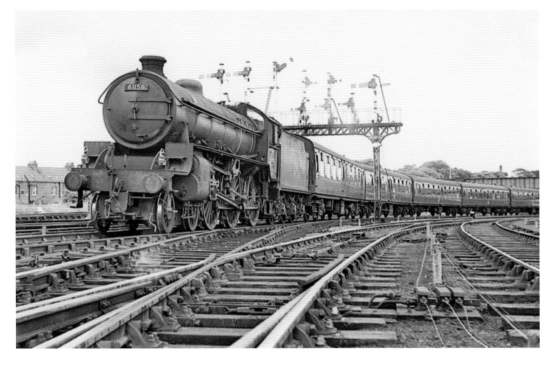

Bridlington Station

Passing under the signal gantry south of Bridlington station is a B1 4-6-0 at the head of a train for Doncaster. A special train ran along the Hull–Bridlington line to commemorate the end of steam, hauled by ex-LNER K1 2-6-0 No. 61994 *The Great Marquess* (now a resident of the Severn Valley Railway and regular on the Mallaig trains), assisted by another K1 No. 62005, both arriving at Bridlington on the tour.

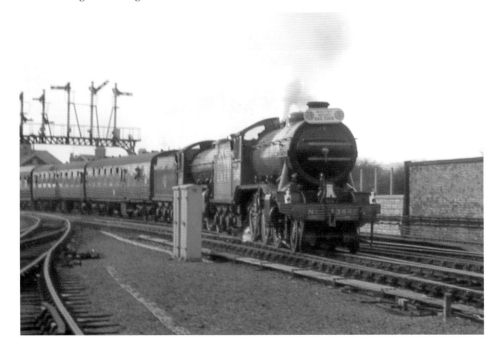

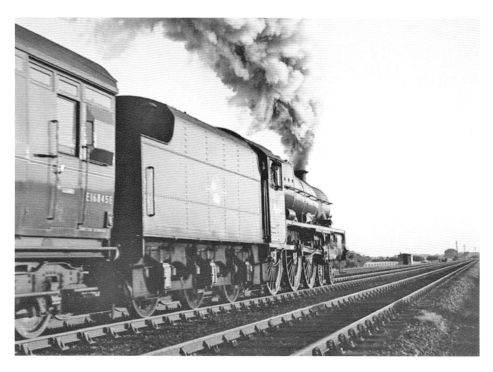

An Excursion to Bridlington
A pair of views of ex-LMS Stanier Jubilee Class 4-6-0 No. 45694 *Bellerophon* on an excursion to Bridlington.

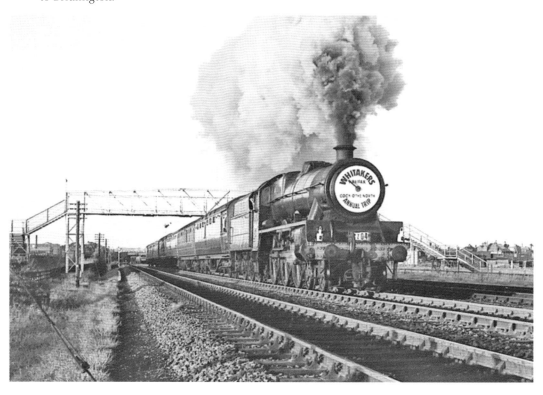

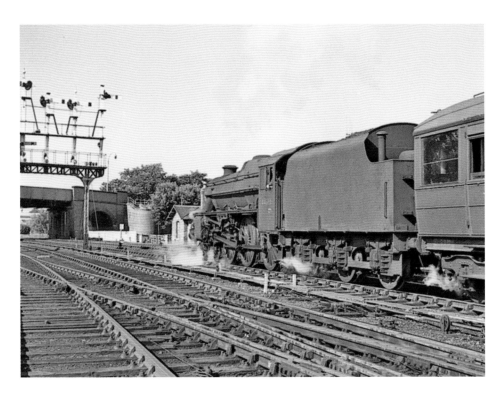

Bridlington Station
The central platform at Bridlington station in August 1970 with a couple of DMUs in view above, and below, the platform under the canopy.

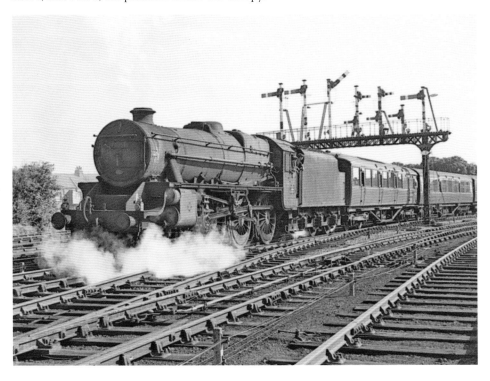

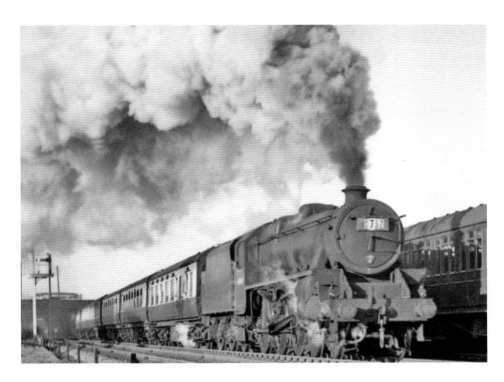

Bridlington Station

Above is an ex-LMS Black Five 4-6-0 on a return excursion from Bridlington while, below, a shabby looking V2 2-6-2 No. 61807 is seen departing from Bridlington in September 1964.

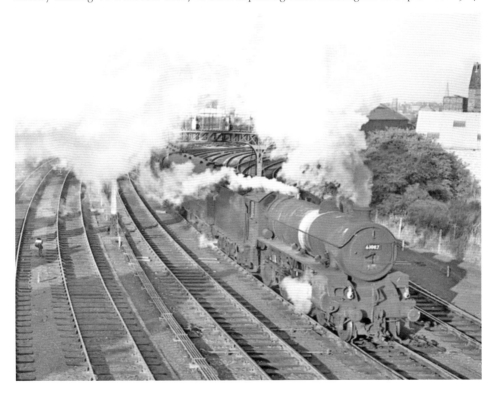

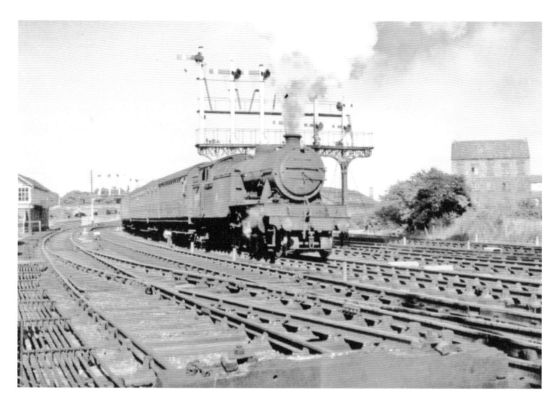

Bridlington Station
Passing Bridlington South signal box in 1958 is Class V3 2-6-2T with a local service for Hull while, below, on 27 April 1953 a train is departing Bridlington, heading south, and past Bridlington loco shed, with an ex-LNER locomotive in view.

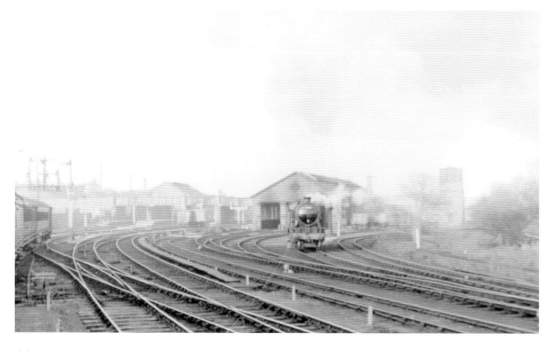

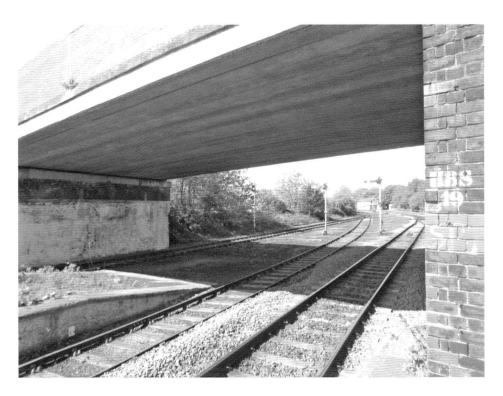

Bridlington South Signal Box

A view of Bridlington South signal box from the platform end in May 2014. The loco shed would have been to the left of this view. Below, waiting outside Bridlington shed is ex-LNER B1 4-6-0 No. 61237, *Geoffrey H. Kitson.*

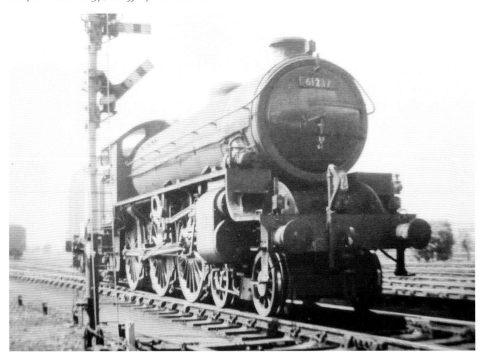

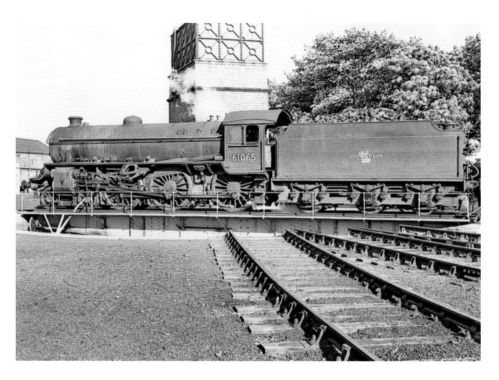

Bridlington Station
An unidentified K1 2-6-0 is sitting on the turntable at Bridlington in the early 1960s. Below, a Class B16 4-6-0 No. 61447 simmers at the shed throat in the same period.

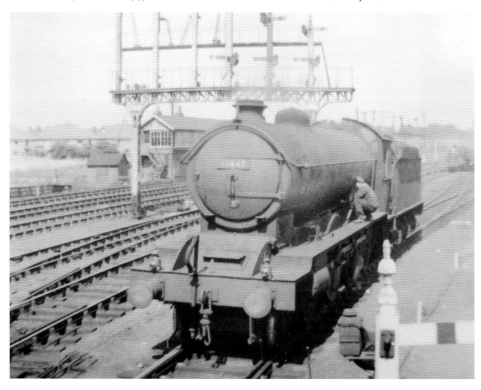

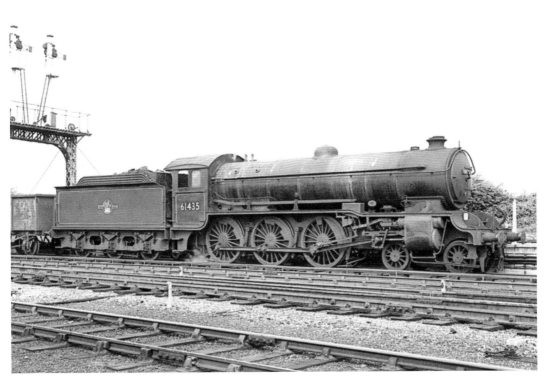

Bridlington Coal Staithes
Another B16, No. 61435, is seen at Bridlington coal staithes, while Class K2 2-6-0 No. 61752 sits outside the shed in the 1960s.

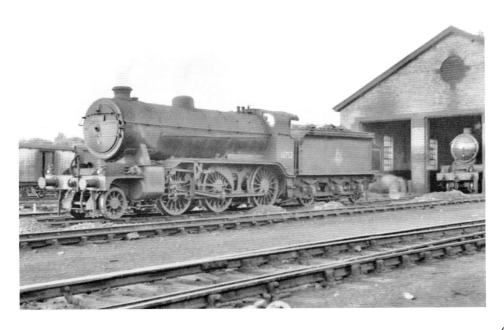

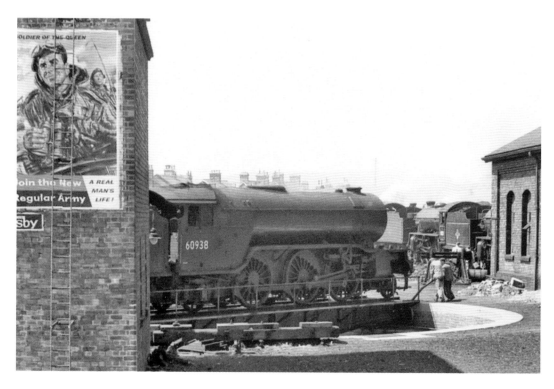

Bridlington Station

A good view of the turntable at Bridlington, with an unidentified locomotive being turned above, while below, a foreign engine, ex-LMS 2-6-0 Crab No. 42724, has just arrived at Bridlington shed, having brought in an excursion from the West Riding or Lancashire.

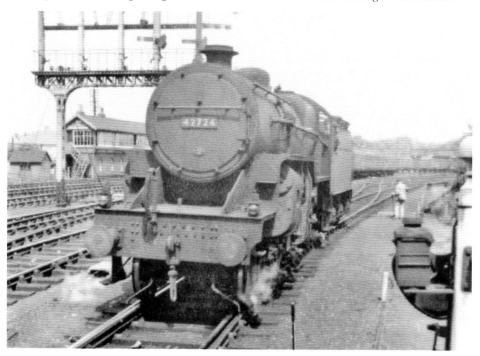

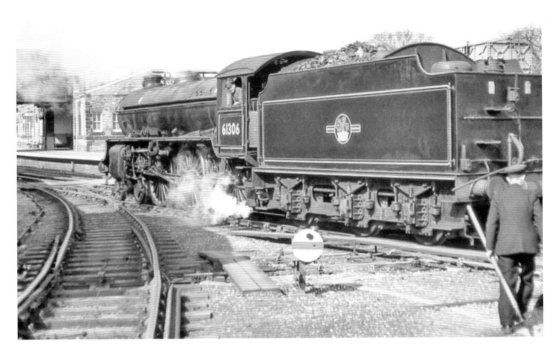

Bridlington Shed

Above, on the turntable at Bridlington shed is an ex-LNER locomotive in April 1965. In the same period, BR Standard Class 5 4-6-0 No. 73018 is standing outside the shed below.

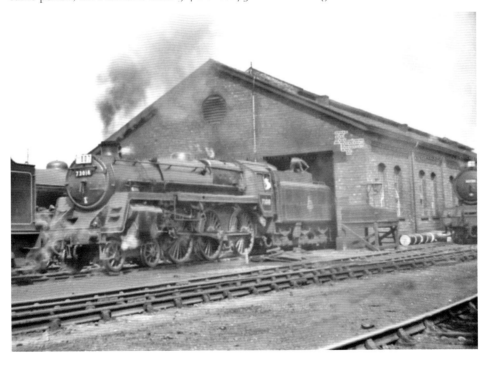

Bridlington Shed

Above, standing outside the shed, is B1 No. 61115 and an unidentified ex-LMS Black Five 4-6-0. Below is another B1 No. 61131 at the shed in the same period. At the peak of the summer season, Bridlington would often see engines from other areas of the country, particularly ex-LMS types, which brought in excursions from the West Riding, Lancashire and the West Midlands. These engines were maintained and serviced at Bridlington before returning to their homes with the return workings in the evening. Even when the shed was closed to normal traffic in December 1958, it still took responsibility for steam engines until such traction ceased.

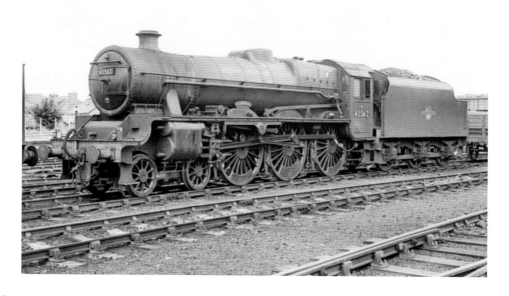

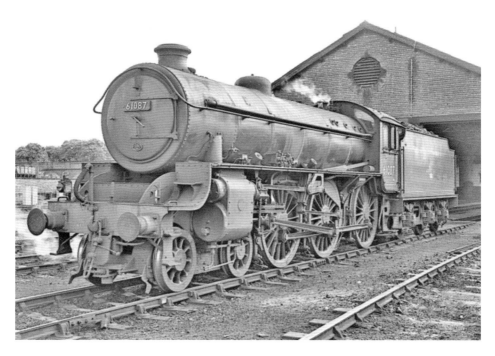

Bridlington Shed
Standing outside the shed in August 1964 is another B1 No. 61087 in company with a couple of ex-LMS Black Five 4-6-0s.

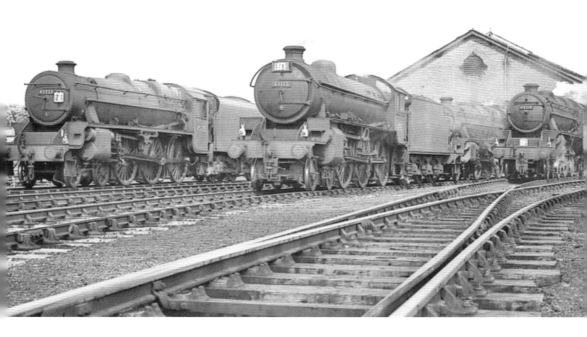

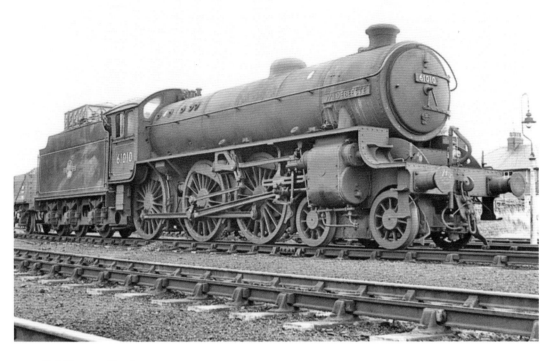

Bridlington Shed
A couple of B1s at Bridlington. Above is No. 61010 *Wildebeeste,* and below is No. 61087 taking on water.

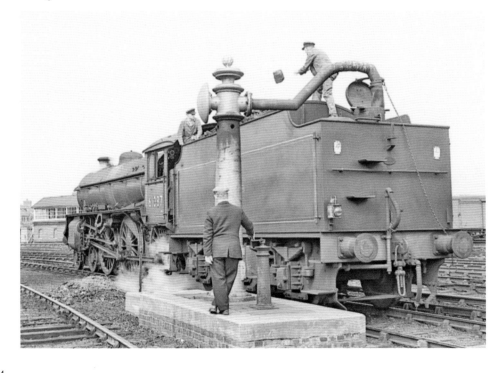

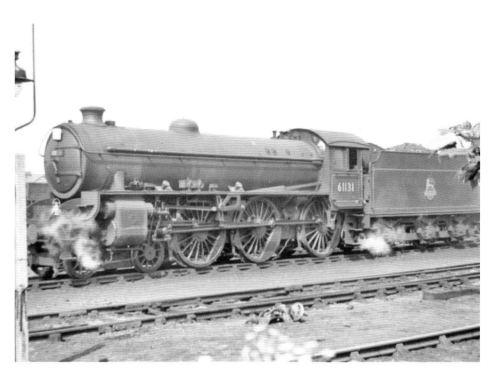

Bridlington Shed
Standing outside Bridlington shed is another Foreigner in the shape of ex-LMS Jubilee 4-6-0 No. 45562 *Alberta*. Below, the shed has long gone and replaced by a B&Q store, seen here in May 2014.

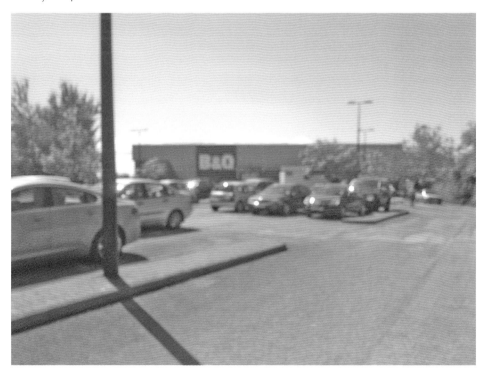

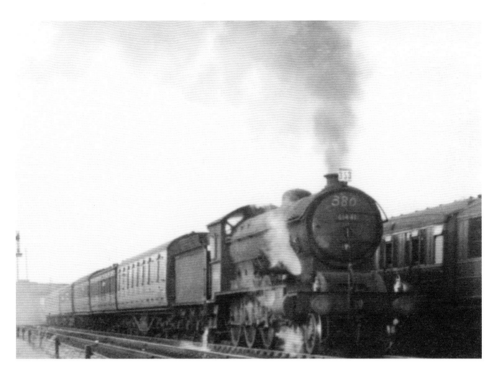

Bridlington Station

Above, arriving at Bridlington is B16/1 4-6-0 No. 61441 while, below, another B16, No. 61438, is departing from Bridlington with a train to Butlins' holiday camp at Filey, which had its own station on a short branch off the main line between Hunmanby and Filey. This little branch closed as holiday business reduced in the late 1960s.

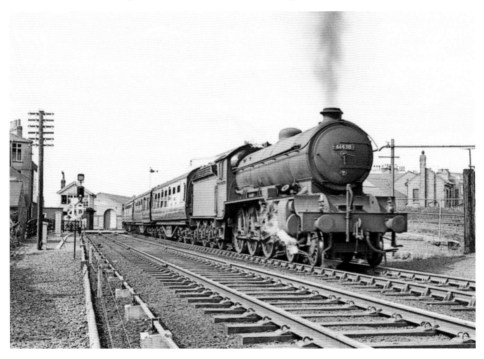

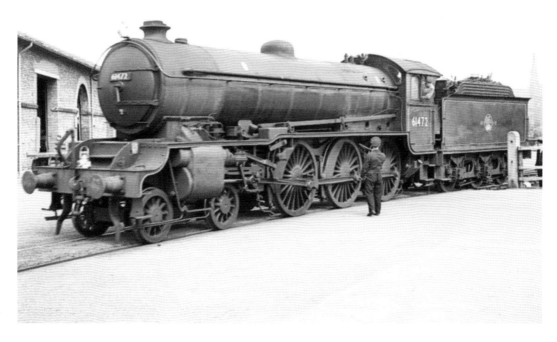

Bridlington Goods Yards

Above, another B16, No. 61472, is resting in the substantial goods yard at Bridlington, which has long since disappeared as more freight traffic has been removed by road. B16 No. 61463 is seen below in the goods yard.

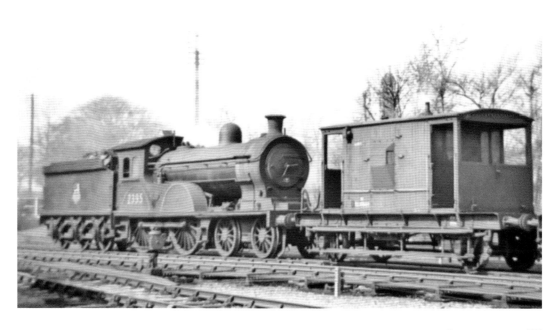

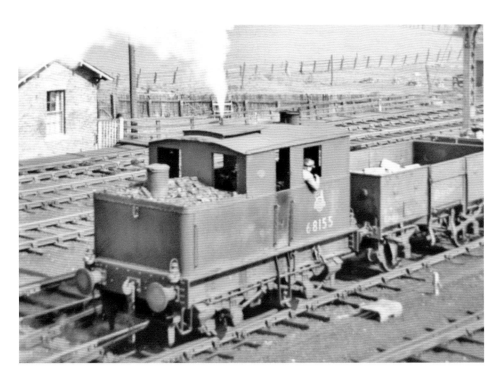

Bridlington Goods Yards

Above, the little Sentinel Class Y3 0-4-0 shunter No. 68155 is on duty in the goods yard, while ex-WD 2-8-0 No. 90704 is leaving the yard with a freight train below.

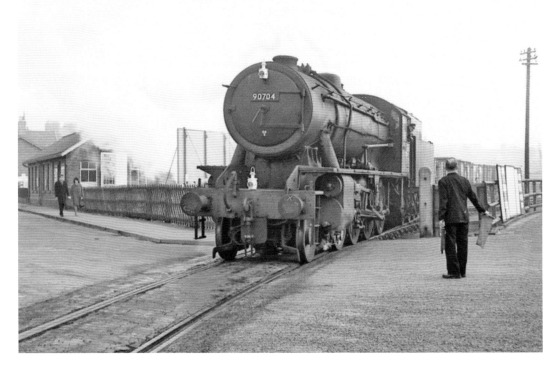

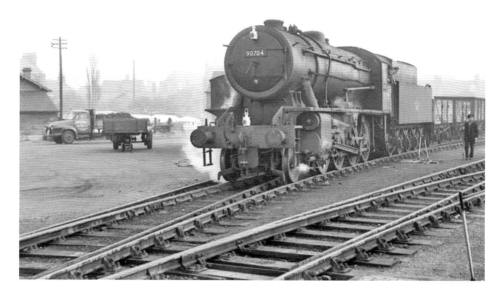

Bridlington Goods Yards

Locomotive No. 90704 is seen once again at Bridlington goods yard in the above view, while below, another WD engine, No. 90878, is seen leaving the yard with a goods train.

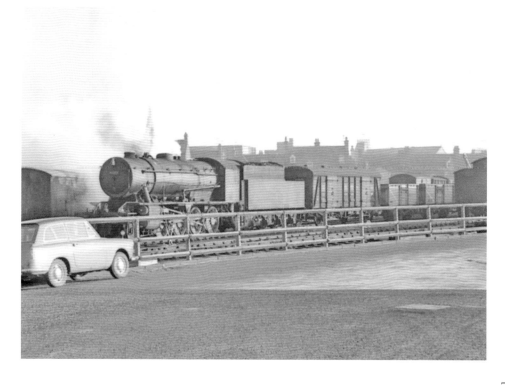

Bridlington Goods Yards
Another ex-WD 2-8-0 is seen shunting in the yard at Bridlington while a Class D20 4-4-0, No. 62395 shunts a brake van in the yard. At this time, the D20 would have been near the end of her working life.

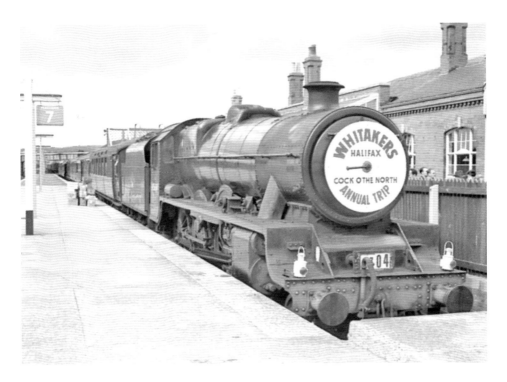

Bridlington Station

Above, standing at the excursion platform is *Bellerophon* with its excursion headboard for Whittakers' annual trip. Below is a train leaving the goods yard and heading towards the station.

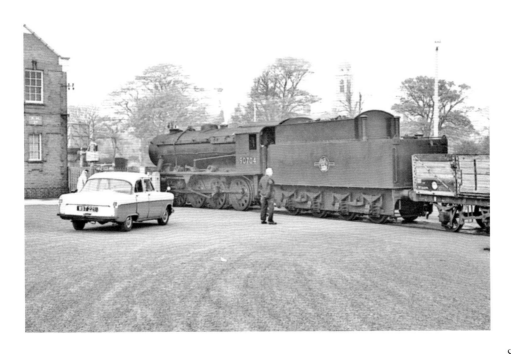

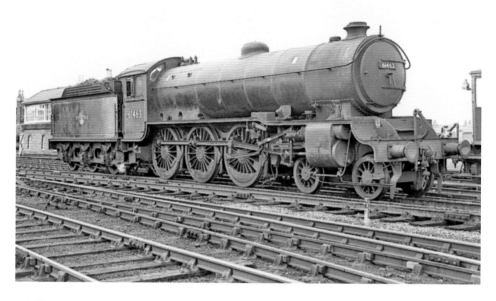

Bridlington Station

Locomotive B16 No. 61463 is waiting at Bridlington for its next turn of duty, while a double-headed train with locomotive D49 4-4-0 No. 62750 *The Pytchley* ahead of an unidentified K3 2-6-0 arriving at the station.

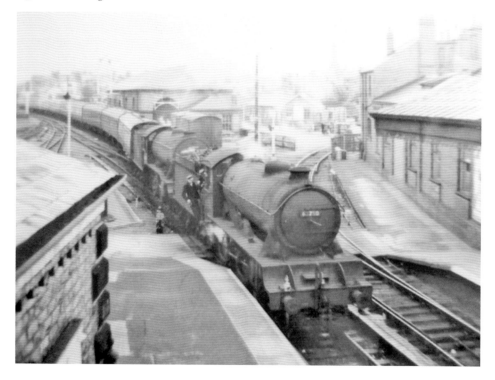

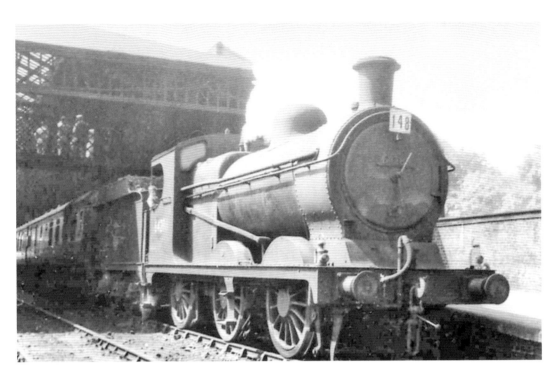

Bridlington Station
Above is an unidentified 0-6-0 at Bridlington station after bringing in a train from Sheffield. Below, an unidentified 2-6-0 is preparing to depart with its train for Filey camp.

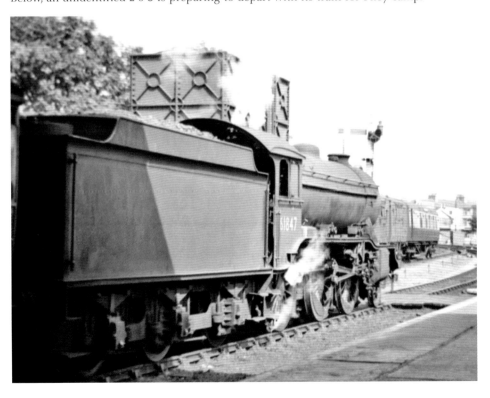

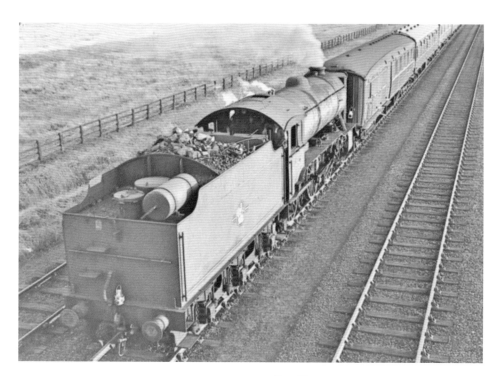

Bridlington Station

In 1952, another 2-6-0 shunts coaches into the carriage sidings. At the peak of the summer, much coaching stock was kept at Bridlington and other sidings on the line, as well as at Filey camp, as it would be required for return excursions later that day. Below, ex-WD 2-8-0 No. 90704 waits for the road to head south with a freight train.

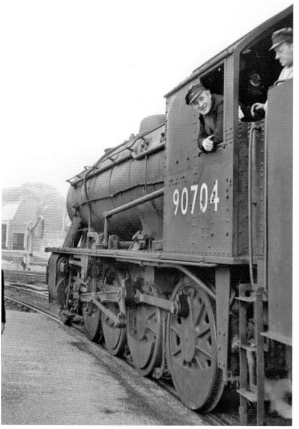

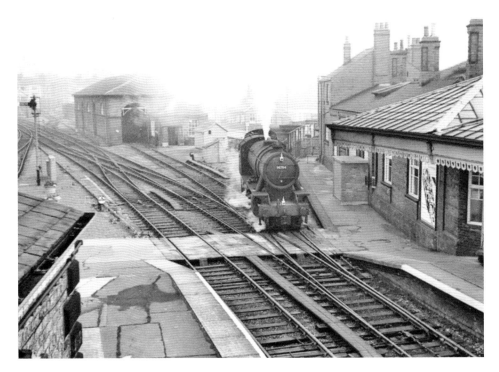

Bridlington Station
A locomotive is seen coming off the goods yard and into the station in the top view, while, at the bottom, the front of B1 4-6-0 No. 61087 is seen as it waits to depart from the station.

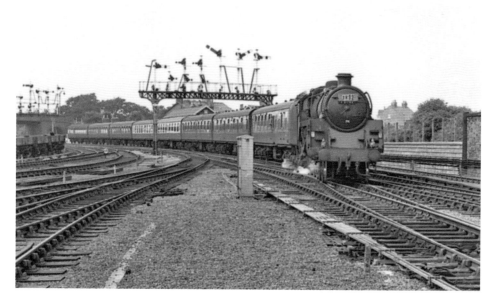

Bridlington Station

Approaching Bridlington from Hull is BR Standard Class 5 4-6-0 with a special train while unusual motive power, in the shape of ex-LMS 4F 0-6-0, is arriving at Bridlington with an excursion train for Scarborough – a small engine for such a large train.

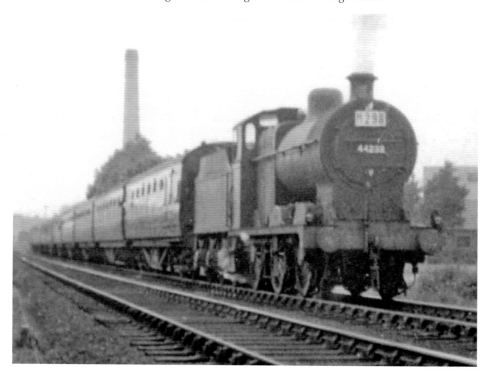

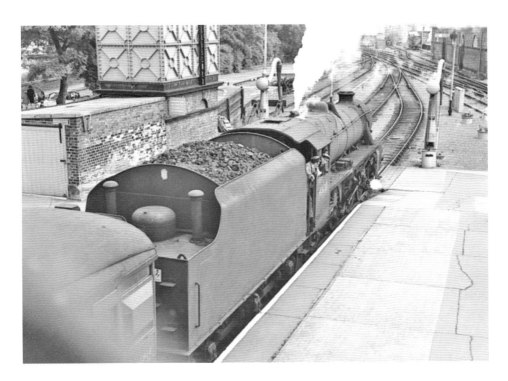

Bridlington Station
Above is another Black Five, No. 45133, waiting to depart with another excursion from Bridlington. Also at the excursion platform is an ex-LNER engine.

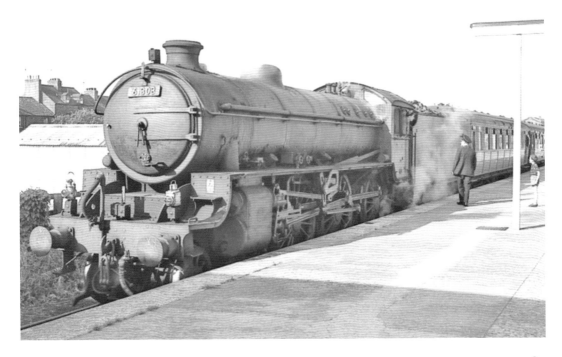

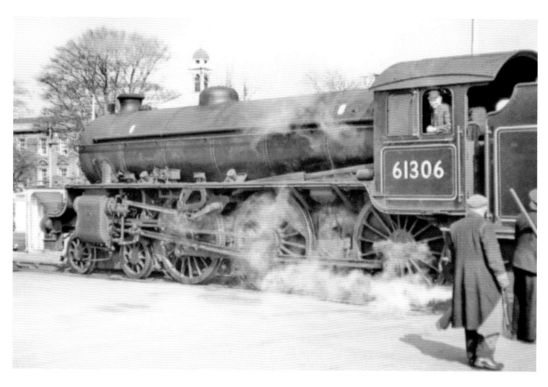

Bridlington Station

Above, sitting at the end of Bridlington station is B1 No. 61306. Below is the Quay Crossing signal box.

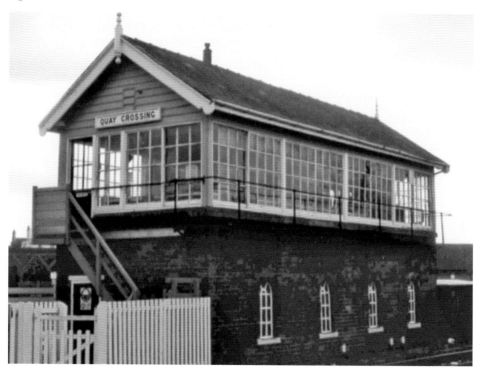

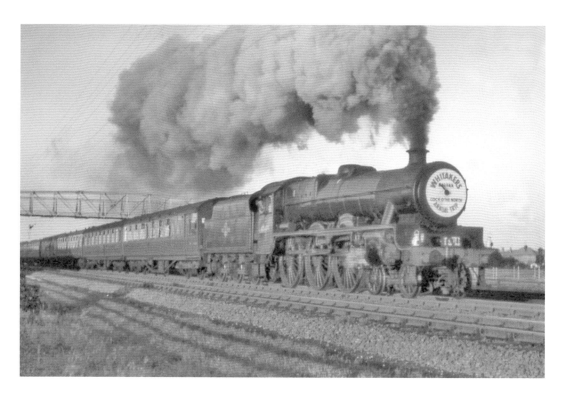

Bridlington Station

The upper view shows Jubilee 4-6-0 *Bellerophon* as it departs Bridlington on the return excursion for Whittaker's. Below is a general view of Bridlington station in August 1967, the final full year of steam on British Railways. A Black Five is preparing to depart with a return excursion to the West Riding, while a DMU approaches the platform with a normal service from Scarborough to Hull.

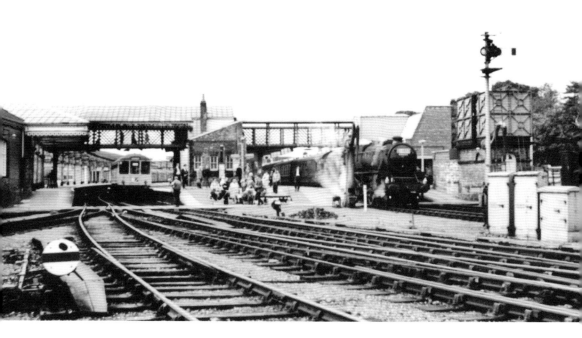

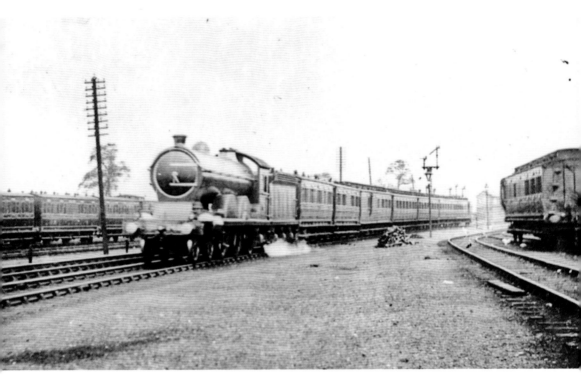

Bridlington Station

Back before the Second World War, ex-NER Class C6 Atlantic No. 742 was allocated to Bridlington shed from June 1939 for eighteen months. It is seen in the above view. Below, on 27 April 1954, ex-LNER Class L1 2-6-4T No. 67755 is waiting beyond the platform end at Bridlington station.

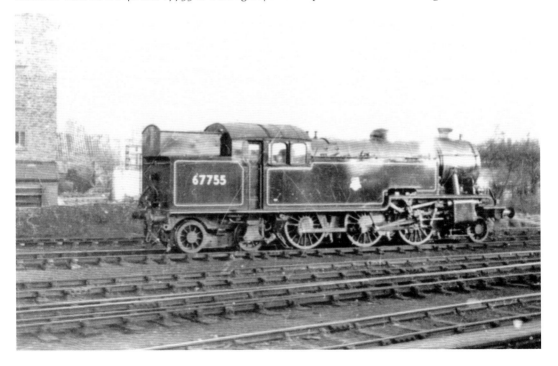

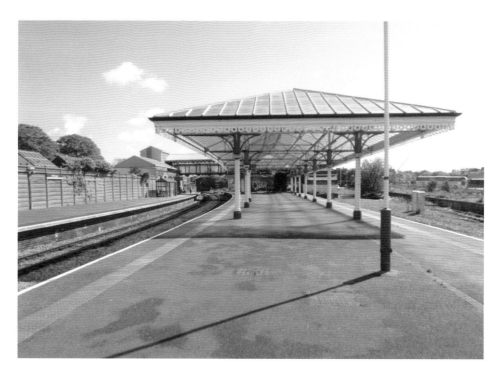

Bridlington Station

The platform canopy at Bridlington station in May 2014 shows little change from earlier views, although the track layout is somewhat different thanks to rationalisation. Below, looking from the canopy, a Scarborough-bound train has just arrived from Hull.

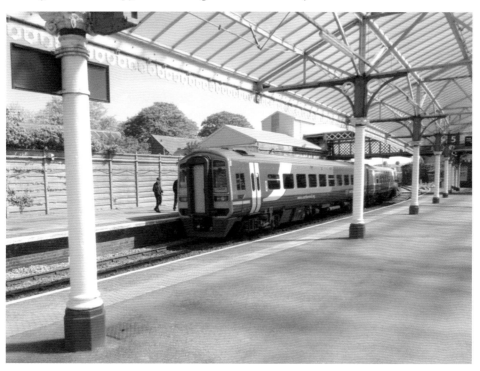

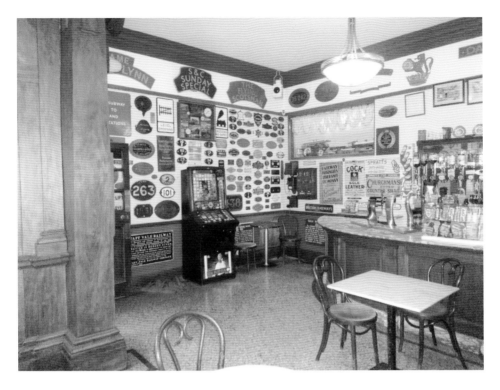

Bridlington Station

The bar at Bridlington station in May 2014 with train headboards and other memorabilia on the walls, along with a well-stocked bar. Below is the buffet at the station with advertisements and posters adorning the walls. Below, a member of staff is looking on.

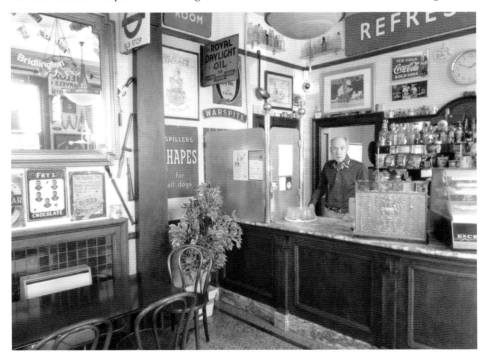

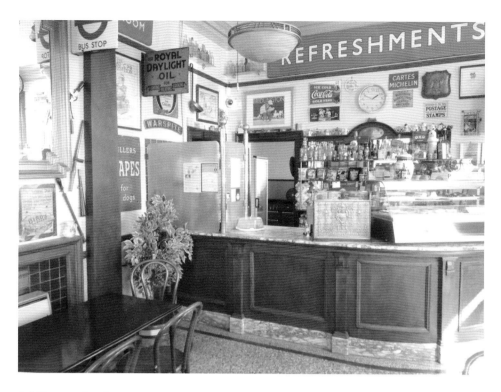

Bridlington Station

Another view of the buffet at Bridlington station, an attractive place to enjoy a cup of tea. Below is the concourse at Bridlington station with flower tubs and seating scattered around.

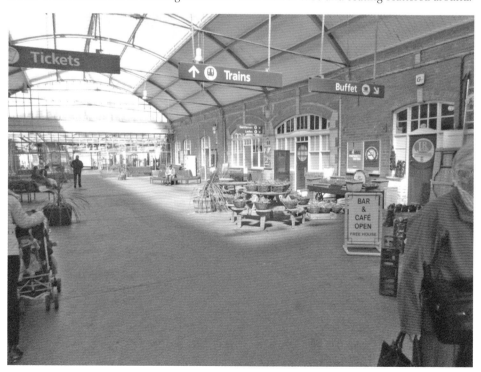

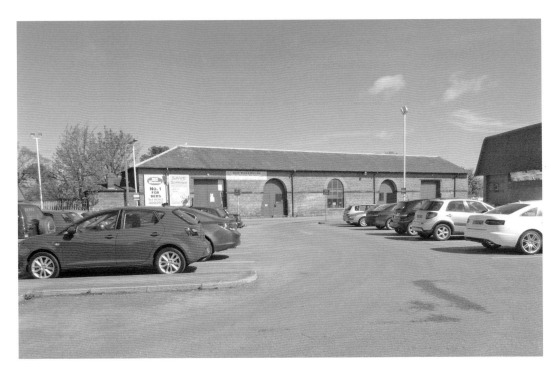

Bridlington Station

Above, on the outer concourse of the station is the old goods warehouse, which, in May 2014, is now the Bed Warehouse. Below, back in August 1967, is the exterior of the main station building, which appears busy with passengers, probably awaiting excursion trains.

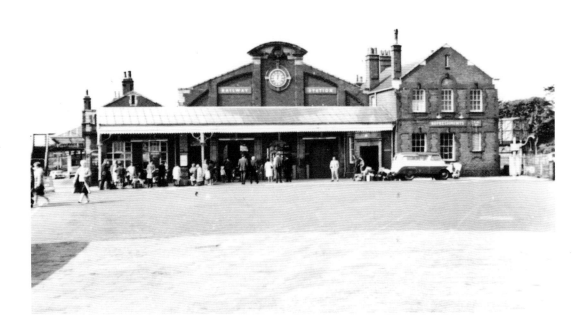

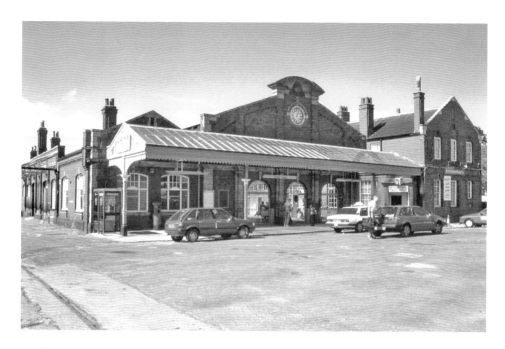

Bridlington Station

Another view of the station exterior in August 1970, which appears much quieter than the previous view, probably because visitors use their cars to visit the town. The final view of the station is in May 2014, with a busy car park, now used by commuters who can enjoy a half-hourly service between Bridlington and Hull. The same cannot be said for passengers travelling between Bridlington and Scarborough, where services can be as infrequent as two-hourly thanks to singling of the line to Seamer, where it joins the York–Scarborough main line.

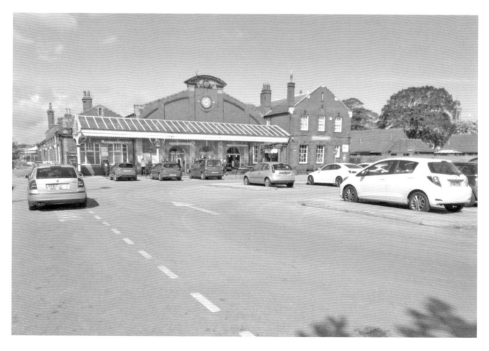

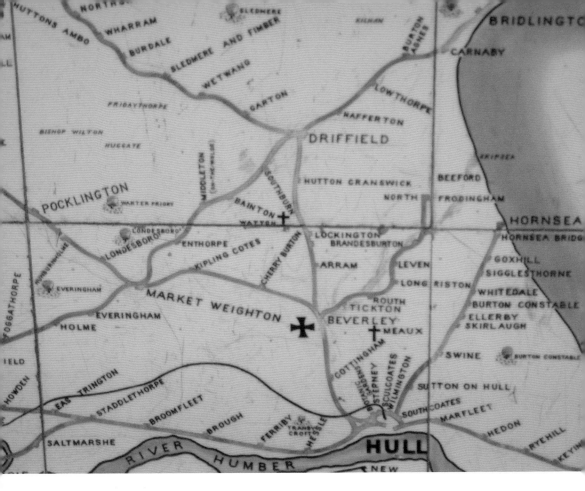

Section of the Tile Map at Beverley Station

The final view shows a section of the tile map at Beverley, which shows the line between Hull and Bridlington, along with the branches at Driffield and Beverley. The map also shows the non-existent branch to North Frodingham. As the map was in tile, it would have been impossible to have that branch removed from the map, so it remains there for eternity.